SPRAY IT
LOUD

Jill Posener
SPRAY IT LOUD

Routledge & Kegan Paul
London, Boston, Melbourne and Henley

First published in 1982
by Routledge & Kegan Paul Ltd
39 Store Street, London WC1E 7DD,
9 Park Street, Boston, Mass. 02108, USA,
296 Beaconsfield Parade, Middle Park,
Melbourne, 3206, Australia, and
Broadway House, Newtown Road,
Henley-on-Thames, Oxon RG9 1EN
Set in Grotesque 215
and printed in Great Britain by
BAS Printers Limited,
Over Wallop, Hampshire
Designed by John Gibbs

ISBN 0–7100–9458–2

For My Dad Julius and for Sue O'Sullivan with my love

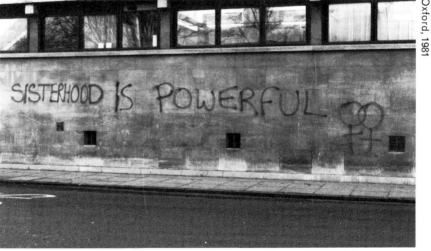

Oxford, 1981

Contents

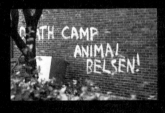
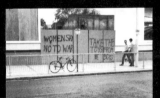

Acknowledgments

The author and publishers wish to express their thanks to the
following for permission to reprint material from copyright works:
Poison Girls (lyrics and graphics)
Kentish Times, 'Animal Belsen'
Pam Isherwood, 'White Horse – Paradise'
Val Wilmer, 'Lesbians Fight'
Dee Aherne, 'Rape in Marriage'
Wendy Hollway, 'Kayser Rapist'
Peter King, BUGA UP Graffiti
Grove Music (Lyrics).

The author's thanks to:

Joyce and Euni
Sybil Grundberg
Helen Bishop
Berta Freistadt
Janey Sugden
Pam Isherwood
Val Wilmer
Wendy Hollway
Dee Aherne
Vi Subversa and Poison Girls
Cecilia, George, Sarah, Kerry, Kate and Jenny
Jackie Plaster
Frankie Rickford and Celia Weston
Ruth McCall
The Mistakes
Outwrite Collective
Spare Rib
Carole Spedding
All the Lesbian Mothers
Spike and friends
John Hoyland
Chris Schwarz
Crass
Freedom Press
London Workers' Group
Animal Liberation Front
Ronnie Lee
Lisa P. and Julie P. Remember Lancaster?
Gay Sweatshop Theatre Co.
Cinema of Women
My Mum
Miriam Margolyes
Billboard Utilising Graffitists Against Unhealthy Promotions (BUGA UP)
Citizens Organisation Using Graffiti to Halt Unhealthy Promotions (COUGH UP)
British Union for the Abolition of Vivisection (BUAV)
Feminist Anti Nuclear Graffiti (FANG)
Calverts North Star Press
Betty Powers
Leeds Women Against Violence Against Women (WAVAW)
Angry Women
Release
and Phillipa, Sally, Harriet and David at RKP.

Finally, to all the spray painters who take all the risks. . .

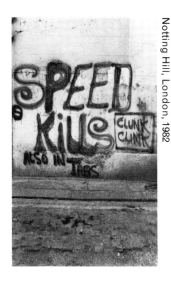

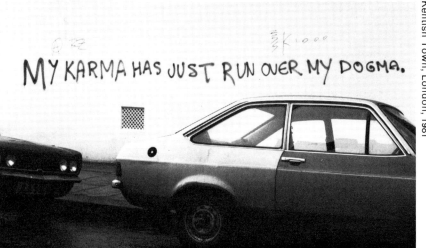

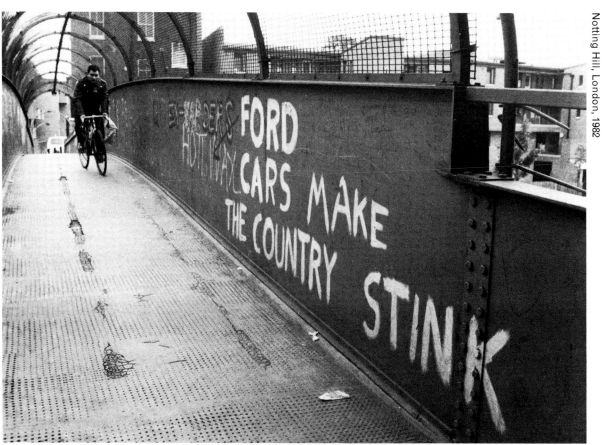

Introduction

People seemed incredulous when I said I was compiling a graffiti book. 'Another one?' they'd shriek. I'd blush and stutter, 'It's different, I tell you.'

But I guess there was no need. The photos speak for themselves, and if they don't always speak right away, this book allows the graffitists a voice in words other than the graffiti.

Graffitists have changed since the days of Kilroy. Nowadays, they are more likely to be women and men committed to some form of social change, and graffiti provides a public forum for their views. Graffiti often acts as a complement to other actions such as demonstrations or campaigns. Leaflets, badges and posters are more traditional means of making your feelings felt. Graffiti, though less orthodox, is no less effective. The feminist movement, No Nukes campaigners, the anti-smoking lobby and anarchists have all become street writers. And, contrary to the media image of all these issues, the graffiti is usually imaginative and often humorous. An innovation has been the refacing of adverts seen as sexist or racist, or promoting drug abuse. The group that coined the phrase, 'A Billboard Without Graffiti Is Something Quite Outrageous,' has waged a single-handed battle on the multi-national corporations in Australia. They maintain that billboards are not only grossly ugly but that they mislead and misinform the consumer, while at the same time teasing us with the products they are promoting. Tobacco and alcohol ads are their main target, though other groups concentrate their efforts on other forms of advertising, ads which, for instance, objectify women's bodies. There are issues, too, which can't be laughed at or made humorous. Animal liberation is one of these. People who have never seen themselves as 'political' are risking arrest because of a deep and committed opposition to the way in which animals are used in laboratory tests for cosmetics or chemical warfare. The photos in this book reflect this diversity.

But the pieces of graffiti that remain fixed in my mind are the ones which have completely changed the nature of an advert or have made a sharp point within a humorous framework. These two forms of graffiti complement each other and provide much needed discussion on the streets. Hoardings are a one-way lecture. Graffiti creates two-way communication. I've been searching the streets of English cities for four years now, ever since I became aware of the aerosol additions to our walls. The Fiat ad with the classic response 'If this lady was a car she'd run you down' was the beginning of a long and valuable relationship. I suppose I'm addicted now. Armed with my *A To Z* I roam the streets with my camera in search of the ultimate graffiti. I'm lucky. I think I've seen the best and more. I make no apologies for some of the harsher comments. They may startle and shock, but they represent real and genuine emotion. Whether it's sad graffiti about the lack of decent housing, or the angry responses to rape attacks, it reminds me that there is resistance and rebellion. And this book should ideally represent those rebellions. Well, I'll let the spray painters speak for themselves. . . .

"This ad was opposite my place of work. I had to stare at it out of the window. A colleague and I went out and added the graffiti. You can see there are two handwritings! It was a way of taking over the poster. You have to have a lot of money to afford billboards like that. We wanted to reclaim the open spaces that have been colonised by advertisers. By writing angry but humorous graffiti, we were also making the point that ad agencies don't have the monopoly on wit. It feels great to see it reproduced everywhere. It's made the point that women can do something instead of just seethe."

WOMEN'S WRITES

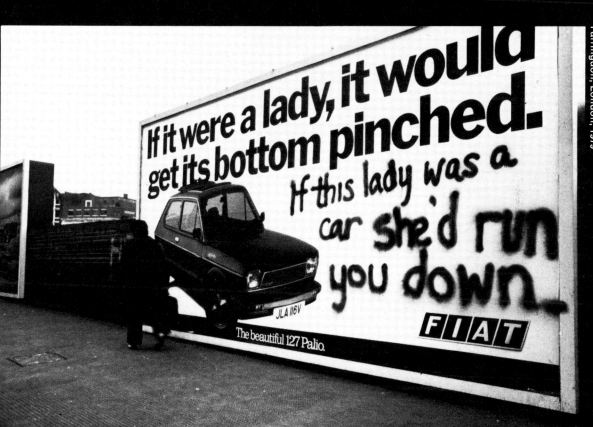

Farringdon, London, 1979

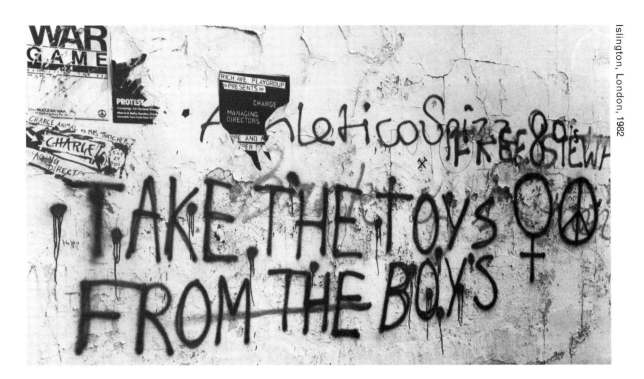

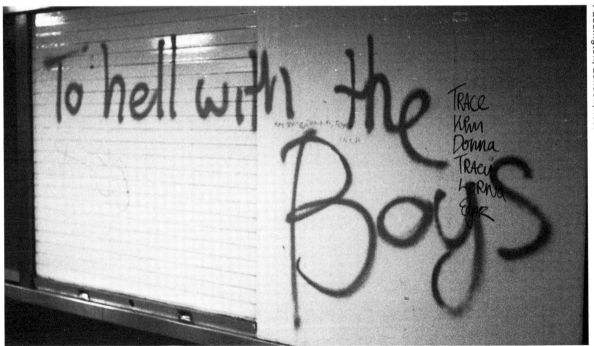

14

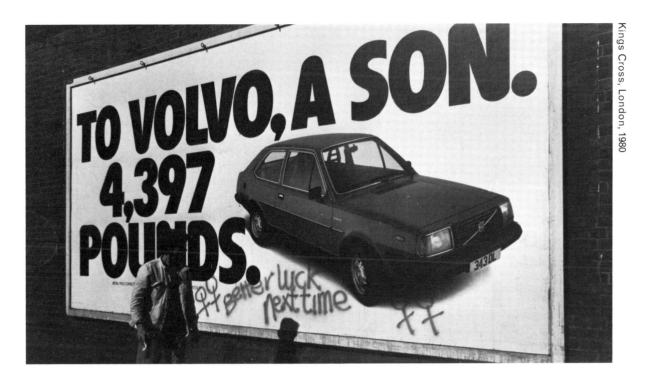

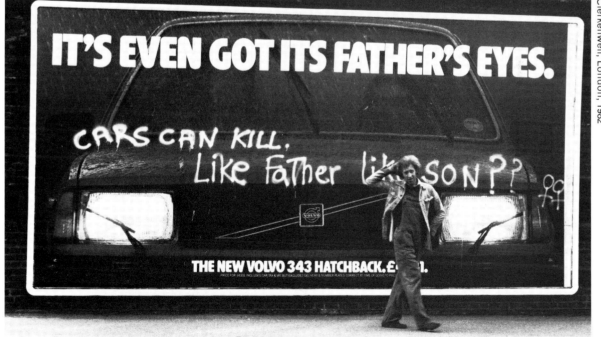

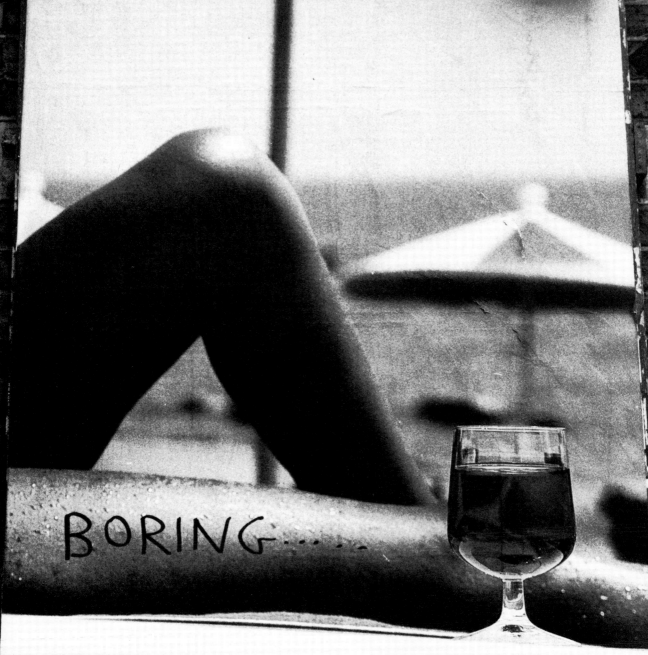

Finsbury Park, London, 1982

Herne Hill, London, 1982

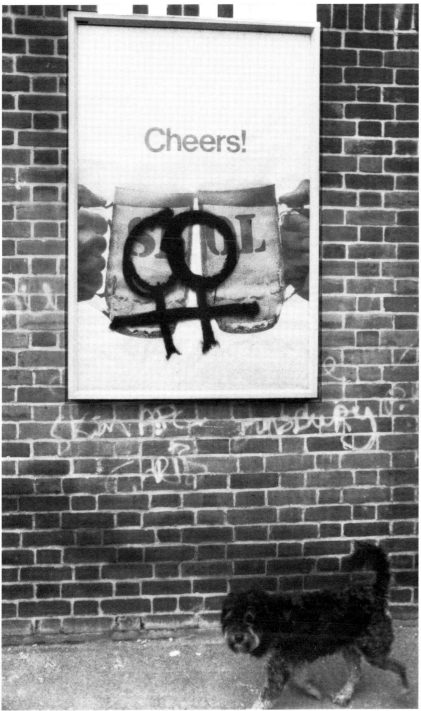

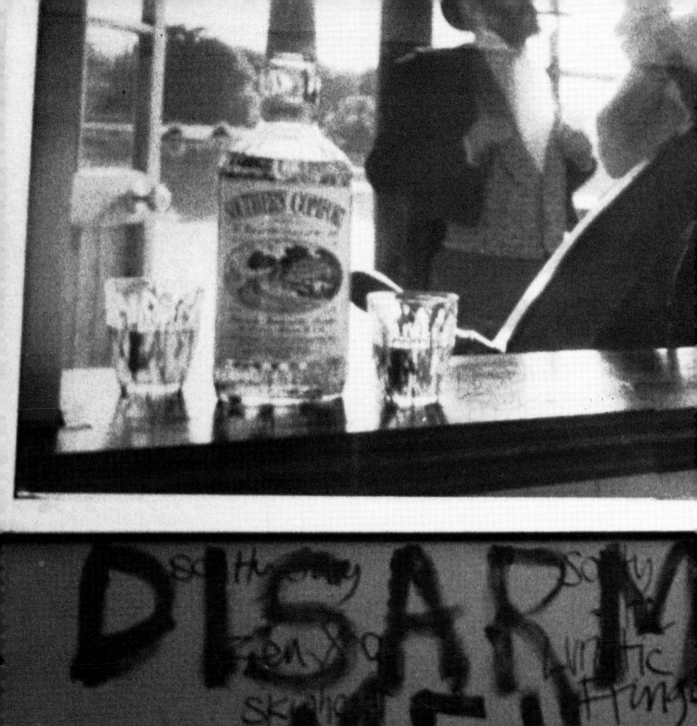

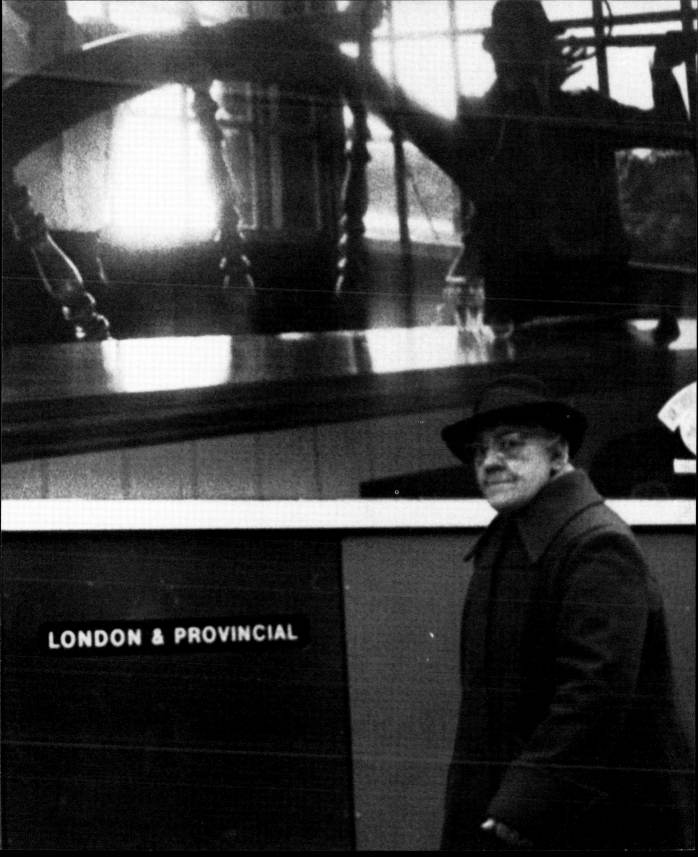

LONDON & PROVINCIAL

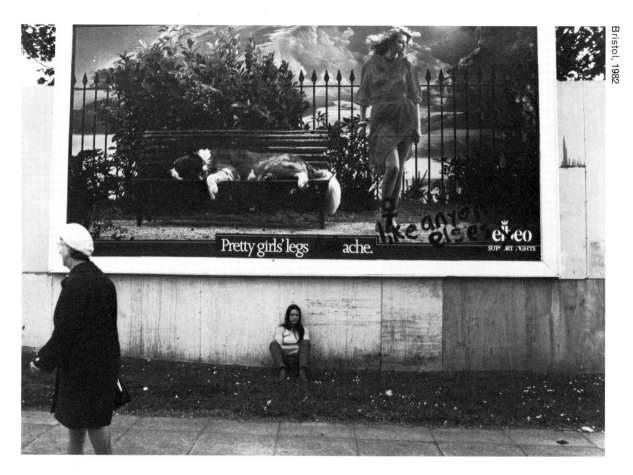

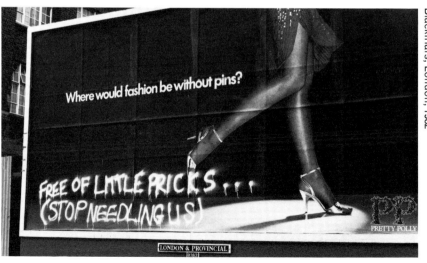

They beat the pants off trousers.

STOP pulling our legs ♀

Pretty Polly brings back lovely legs.

LONDON & PROVINCIAL
1829

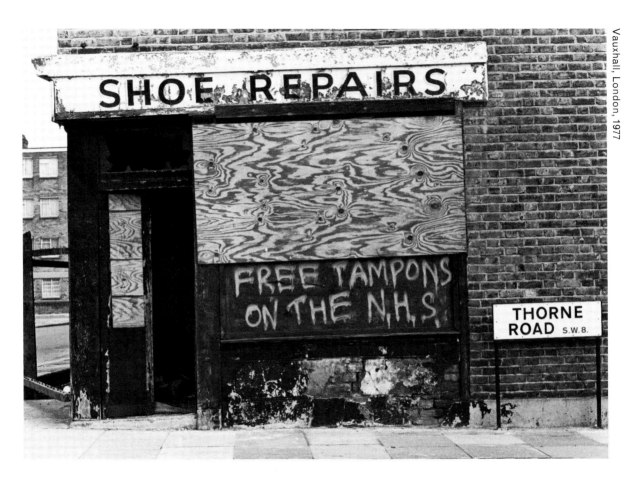

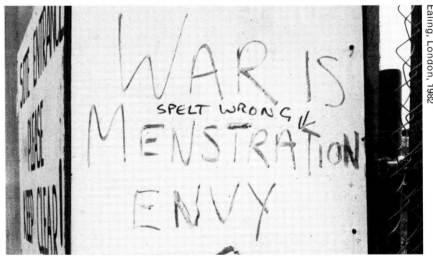

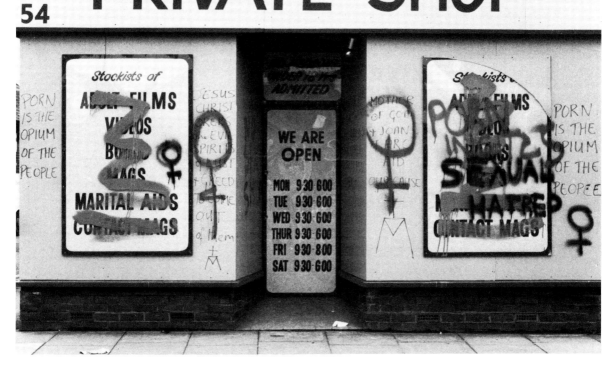

Oxford, 1981

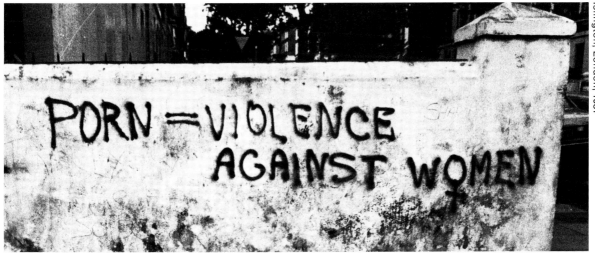

Islington, London, 1981

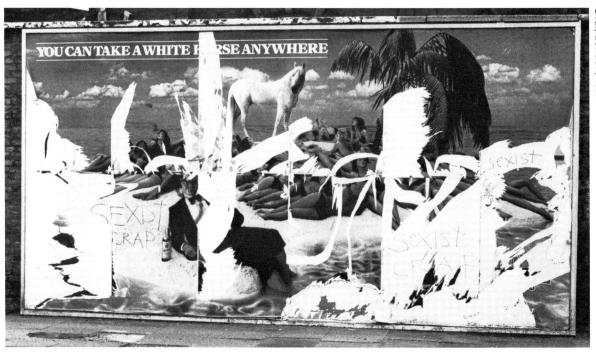

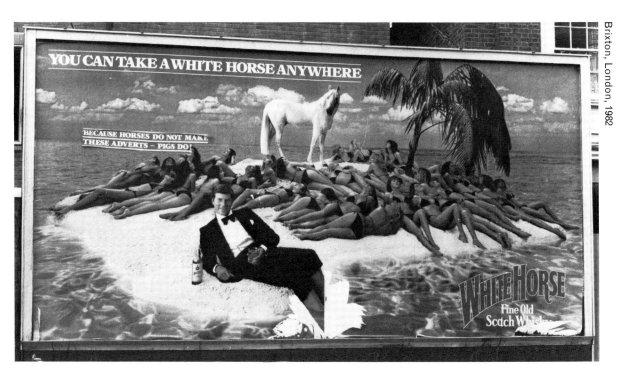

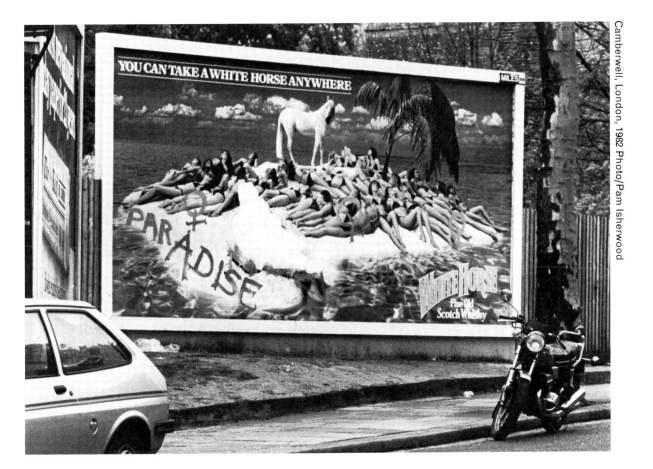

Camberwell, London, 1982 Photo/Pam Isherwood

There are different ways of showing how much you hate a particular ad. This has been a favourite target in 1982. The man has been completely painted out in one instance, the poster has been torn to shreds in another, and, on the third, a clever transfer, using the same lettering as the advertising slogan, has been added.

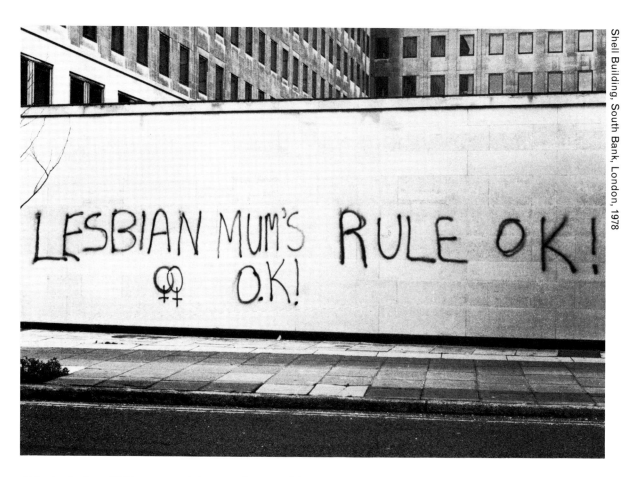

At the beginning of 1978, London's *Evening News* ran a series of articles about lesbians becoming pregnant through AID (Artificial Insemination by Donor). The paper went to ludicrous lengths to get their 'scoop'. They used journalists who 'infiltrated' lesbian organisations, they harrassed lesbian mothers, photographing them with telephoto lenses, trying to create sensationalism and scandal around the issue. They quoted outraged members of the British Medical Association, and attempted to discredit a doctor who supplied AID. The articles, splashed across the front page and double-page spreads, caused a lot of heartache and stress to lesbians and their families. Graffiti, like the one above, appeared all over London, and on

6 January, after one of the articles was published, about 50 lesbians and gay men occupied the offices of what had become known as the *Evening Spews!*

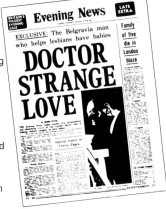

Outside Evening News, London, 1978 Photo/Val Wilmer

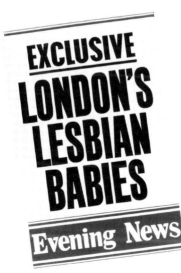

"The invasion of the *Evening News* was our way of striking back at dangerous journalism. The editor, Louis Kirby, admitted he had 'no idea' what harm the articles would do. As we left the building, after winning our demand to a right of reply, men stood outside jeering 'Burn the Queers'. The right of all women to control their bodies was the issue. The right of reply, which appeared the following week, put this point, and stated the case for lesbians to have the right to AID and to have and keep children. As we left the premises, some women, filled with anger, daubed slogans, like the one above, onto *Evening News* vans. One woman, Jackie Plaster, was arrested by a motorcycle policeman and charged with criminal damage to two vans. She was tried by the Lord Mayor of London and fined £30.

"The action was effective for two reasons. First, we had shown that we would not sit idly by, while newspapers play games with our lives, and second, we had shown that direct action does have results. We had won the right of reply in what was then London's largest selling evening newspaper."

27

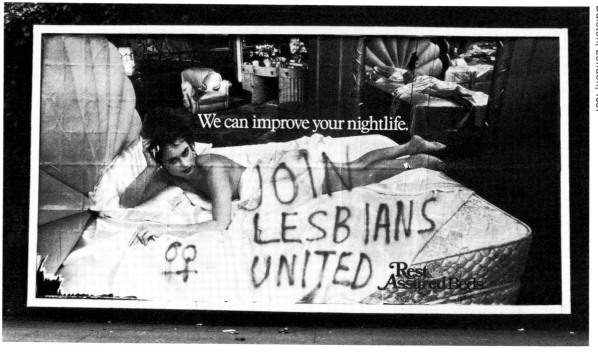

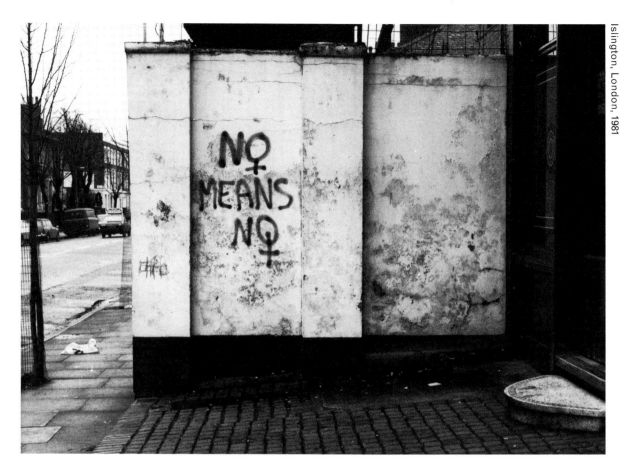

Angry Women is the name adopted by individuals or groups of women when taking illegal action. An *ad hoc* name, it is used and then dropped at random. Their actions include graffiti, criminal damage, and producing stickers to put on sexist book covers, records or posters. Other activities have included attacking sex shops.

"We want to hit men where it hurts – their pockets. They make money out of our bodies and lives. Every time I hear about another woman murdered or raped I feel I could commit violence. But I'm scared and I don't like violence. And, in the end, people just misunderstand our actions unless we're very careful how we publicise them. There are very good spin-offs though. Other women realise they're not alone in feeling anger. If we remain silent, it looks as if we're going along with male violence. Some things we do might seem frivolous, but we're indicating our hatred of the porn industry. What would I like to see? Ideally? All women taking action, saying 'No'. I want to see men change. I want them not to be violent. The reason we are so vehement about porn is that it is propaganda. It tells men it's OK to abuse women. Men get pleasure and power from porn. It teaches them violence. When women see porn we feel intimidated and violated. On that basis alone it should stop."
An Angry Woman, London

Next page: Battersea, London, 1980

WOMEN SAY NO TO

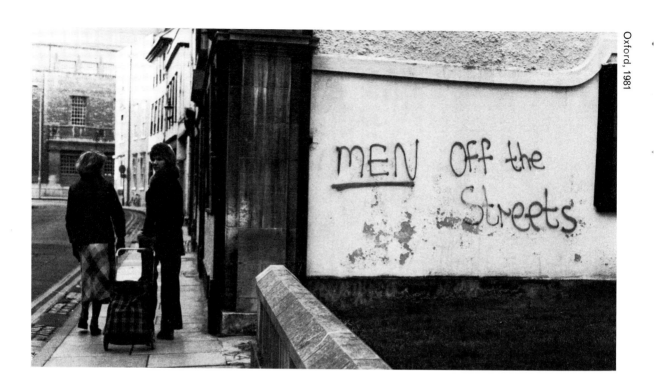

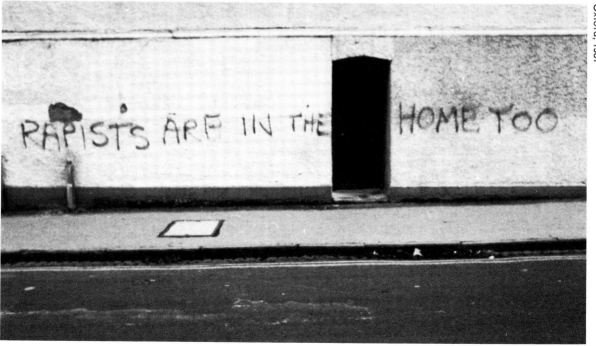

TRINITY UNITED REFORMED CHURCH

SUN		**Minister**	**Notices**
MON	6·15 p.m. CUBS 7·30 p.m. SCOUTS	Rev. R.R.BANCE. BSc.(Ecom)	
TUE	7·30 p.m. SCOTTISH COUNTRY DANCING	**Sunday Services**	
WED		11·00 a.m. & 6·30 p.m. 11·00 a.m. SUNDAY SCHOOL	
THU	7·30 p.m. CH⊘ ONLY		
FRI	6·15 p.m. BR⊘ 7·30 p.m. GU⊘	Licensed for Marriages	
SAT		Church Officer — Mrs. K.STONES. 83 AMBERTON Rd LEEDS.8.	

RAPE IN MARRIAGE- MAKE IT A CRIME

RAPE IN MARRIAGE- MAKE IT A CRIME

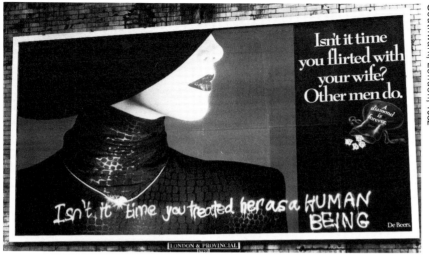

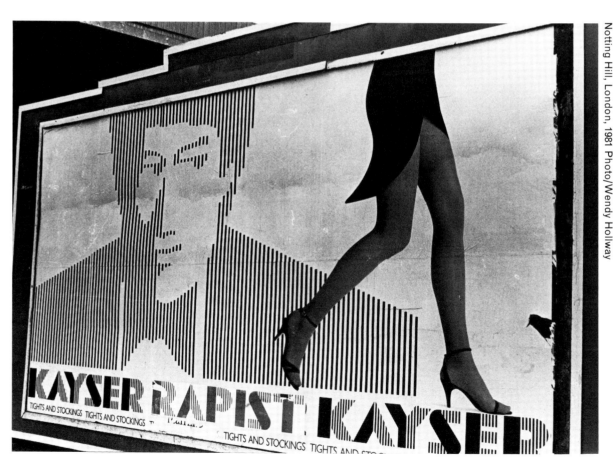

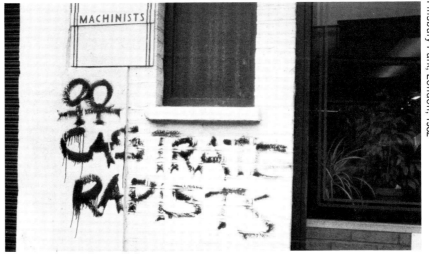

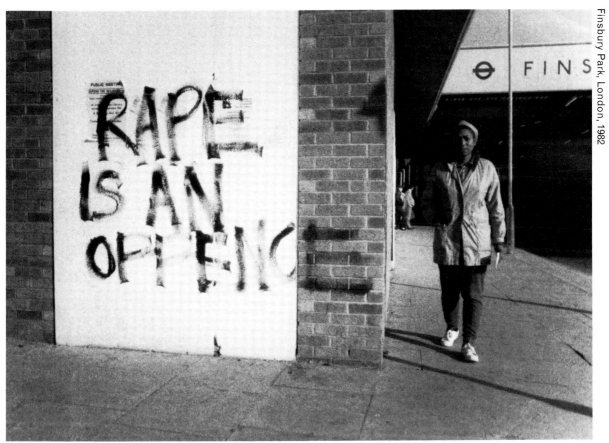

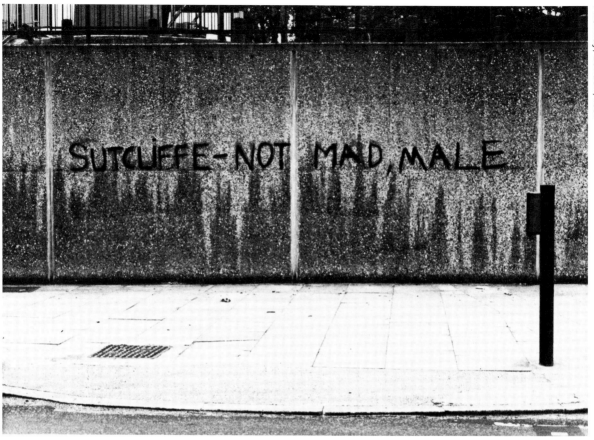

Peter Sutcliffe murdered thirteen women before being caught accidentally. The effect on women's lives in the Leeds-Bradford area was devastating.

"Women gave up evening jobs, baby-sitters wouldn't go out, and evening-class attendances were down. There was always the fear. Boys used to jump out of alleys shouting 'I'm the Ripper' and at Leeds United football ground the cry went up 'Ripper: 12, Police: 0'. Women were united in their fear and their anger. Every woman realised no man could be trusted. Women, not known to each other, would engage in conversation at bus-stops, a women's taxi service started and self-defence classes were inundated with women from all areas. Feminists protested outside sex shops, at cinemas showing violent films and graffiti'd the city. Women who weren't feminists supported the action, but from a discreet distance. Since Sutcliffe, some of the taunts have remained. Some men have a morbid hero worship for the man who kept all women afraid. And, although there is a higher awareness of male violence, women have said they feel safer now that Sutcliffe has been jailed. But women keep being murdered. It doesn't stop. That's what the graffiti means. He isn't some mad monster as some people would like to think. How do we know which man is the next Sutcliffe? Whether it's thirteen women or one, whether it is a student or a prostitute. Woman hating is woman hating."
Betty Powers, Leeds WAVAW (Women Against Violence Against Women)

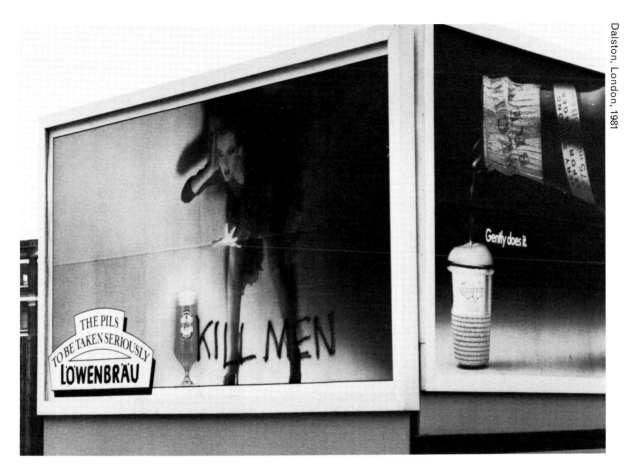

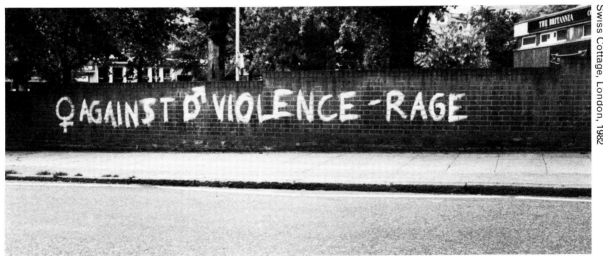

"Proletarians of the world, look into the depths of your own beings, seek out the truth and realize it yourselves: you will find it nowhere else."
Peter Arshinov (1887–?)

"The urge to destroy is also a creative urge."
Michael Bakunin (1814–1876)

PERSONS UNKNOWN

Brixton, London, 1982

GOD IS DEAD
ARE YOU?

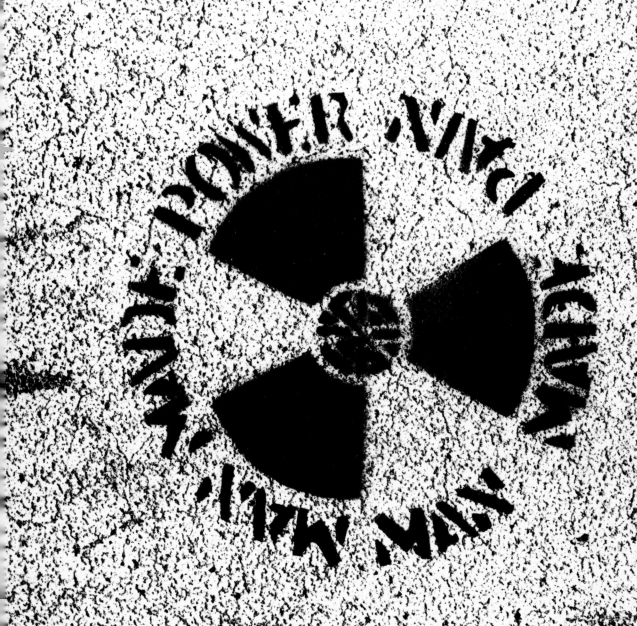

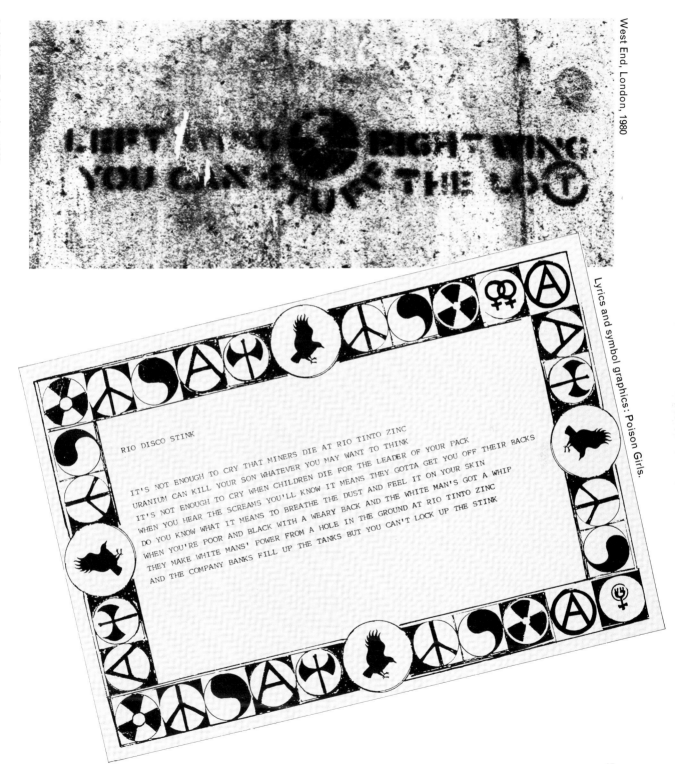

RIO DISCO STINK

IT'S NOT ENOUGH TO CRY THAT MINERS DIE AT RIO TINTO ZINC
URANIUM CAN KILL YOUR SON WHATEVER YOU MAY WANT TO THINK
IT'S NOT ENOUGH TO CRY WHEN CHILDREN DIE FOR THE LEADER OF YOUR PACK
WHEN YOU HEAR THE SCREAMS YOU'LL KNOW IT MEANS THEY GOTTA GET YOU OFF THEIR BACKS
DO YOU KNOW WHAT IT MEANS TO BREATHE THE DUST AND FEEL IT ON YOUR SKIN
WHEN YOU'RE POOR AND BLACK WITH A WEARY BACK AND THE WHITE MAN'S GOT A WHIP
THEY MAKE WHITE MANS' POWER FROM A HOLE IN THE GROUND AT RIO TINTO ZINC
AND THE COMPANY BANKS FILL UP THE TANKS BUT YOU CAN'T LOCK UP THE STINK

45

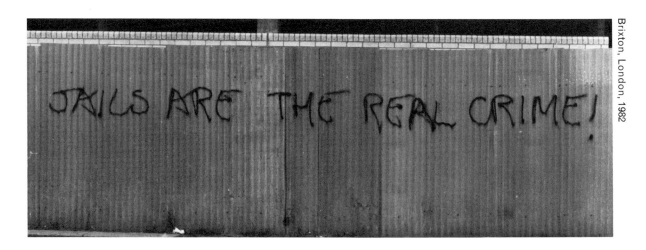

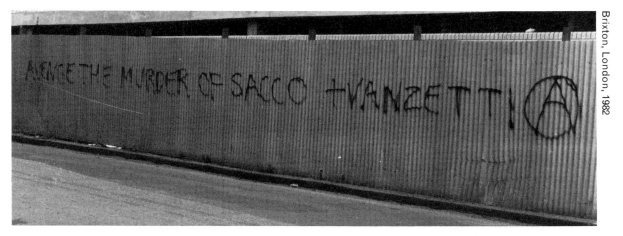

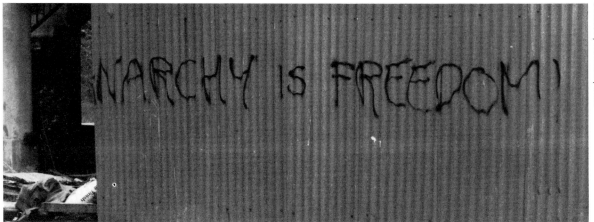

Bartolomeo Vanzetti and Nicola Sacco were executed for crimes they did not commit on 23 August 1927 in Massachusetts, USA. Fifty years after their deaths in the electric chair, the state of Massachusetts admitted that Sacco and Vanzetti were denied a fair trial which led to their executions. The state governor signed a proclamation removing the 'stigma and disgrace' attached to the two men.

The extraordinary events which led to their killings began with two armed robberies late in 1919 during which someone was shot dead. Though both men were avowed anarchists, there was no evidence linking them to the crimes which were apparently committed by known gangs of thieves. There was, indeed, a great deal of doubt as to their guilt even among the legal profession. There were so many discrepancies in the case, including unreliable identification and ballistics evidence, it seems unreal that they were convicted. But in a clumsy attempt by the state to wrap up the crimes and strike a blow against immigrant anarchists, two men had to die. After the trial, the judge, Webster Thayer announced to anyone who wanted to listen 'Did you see what I did to those anarchist bastards?'

The two men languished in jail for seven years before dying; seven years which were spent in appeals and legal delays. But the system, which had kept them in jail and which subsequently murdered them, had made a mistake which it didn't acknowledge until fifty years too late.

Next page: Ealing, London, 1982

Soho, London, 1980 and two 'Persons unknown' badges

Liberty
repressed
by the state

STRANGERS AND PASSERS BY
PERSONS UNKNOWN

RIOTERS AND PACIFISTS
PERSONS UNKNOWN

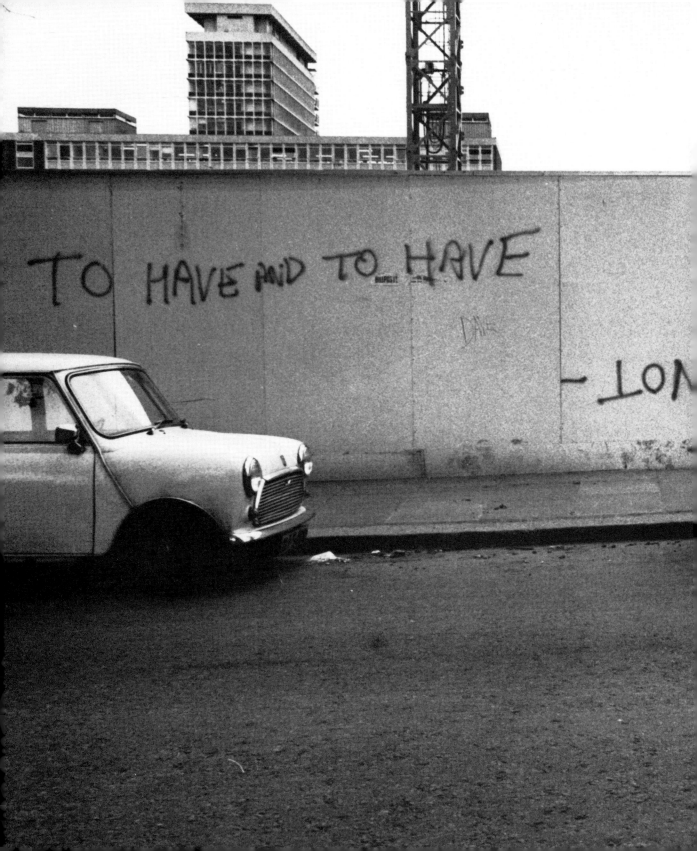

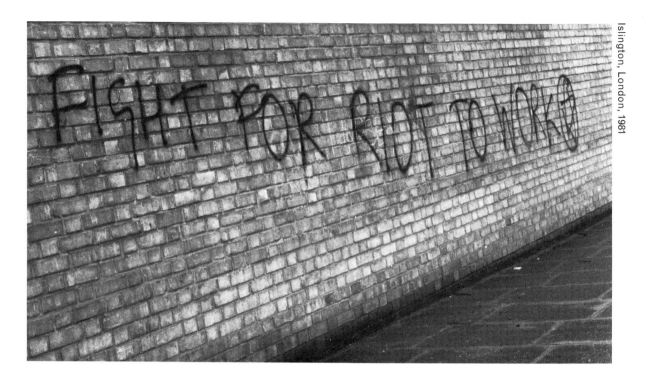

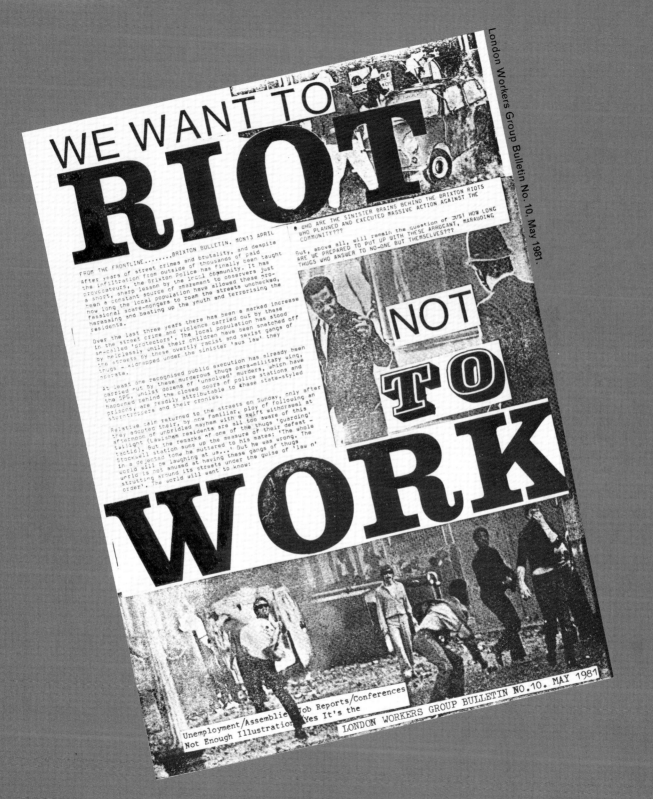

WE WANT TO RIOT.

NOT TO WORK

● WHO ARE THE SINISTER BRAINS BEHIND THE BRIXTON RIOTS WHO PLANNED AND EXECUTED MASSIVE ACTION AGAINST THE COMMUNITY???

But, above all, will remain the question of just how long ARE WE PREPARED TO PUT UP WITH THESE ARROGANT, MARAUDING THUGS WHO ANSWER TO NO-ONE BUT THEMSELVES???

FROM THE FRONTLINE........BRIXTON BULLETIN, MON 13 APRIL
After years of street crimes and brutality, and despite the infiltration from outside of thousands of paid provocateurs, the Brixton local community has finally been taught a short, sharp lesson by the Brixton Police to observers just been a constant source of amazement to observers just how long the local population have allowed these pro-fessional scare-mongers to roam the streets unchecked, harassing and beating up the youth and terrorising the residents.

Over the last three years there has been a marked increase in the street crime and violence carried out by these so-called 'protectors'. The local population has stood by helplessly while their children have been snatched off the streets by these overtly racist and sexist gangs of thugs, kidnapped under the sinister 'sus law' they operate.

At least one recognised public execution has already been carried out by these murderous thugs para-military wing, the SPG, whilst dozens of 'unsolved' murders, which have happened behind the closed doors of police stations and prisons, are readily attributable to these state-styled stormtroopers and their cronies.

Relative calm returned to the streets on Sunday, only after they adopted their, by now familiar, ploy of following an afternoon of unbridled mayhem with a swift withdrawal at twilight (Lewisham residents are all too aware of this tactic). But the remarks of one of the thugs 'guarding' Stockwell station sums up the measure of their defeat - in a dejected tone he muttered to his mates: 'The whole world will be laughing at us...' But he was wrong. The world is not amused at having these gangs of thugs strutting around its streets under the guise of 'law n' order'. The world will want to know:

WORK

51

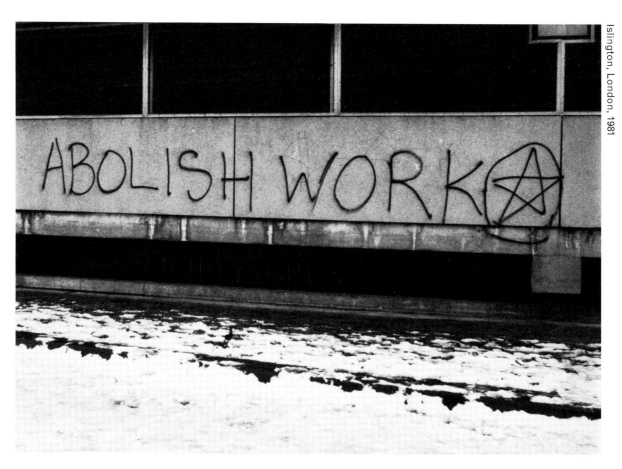

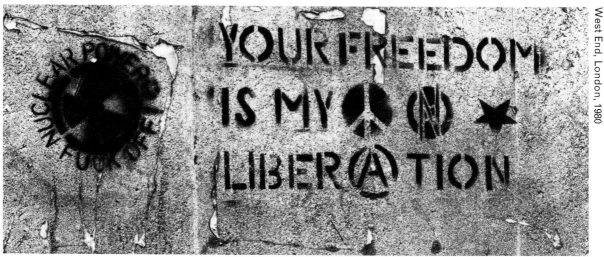

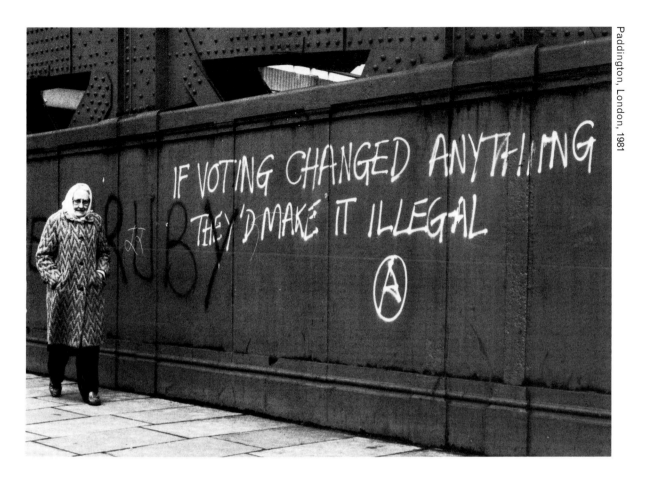

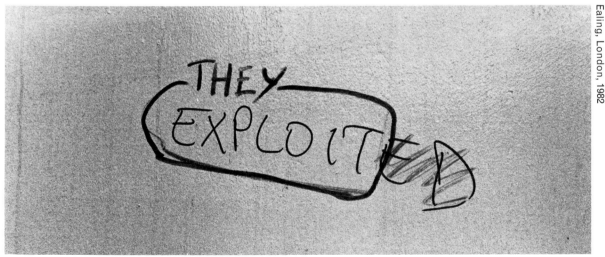

Can't Walk the Streets
No, no I said we can't even walk the streets freely these days
No we can't no we can't these days
Without being accosted and charged with loitering and affray
Sus sus suspicious oh yeah sus sus
What kinda hell is this I said we had our rights
And if we can't get it, if we can't get it
There's gotta be some fight, fight, fight
Because words won't do justice for us
If they won't listen you know fight we must
It probably won't be no sure solution
But I'm telling you there's gonna be a revolution
Donald Benjamin, Aswad, 1979
by permission Grove Music

THE FRONT LINE

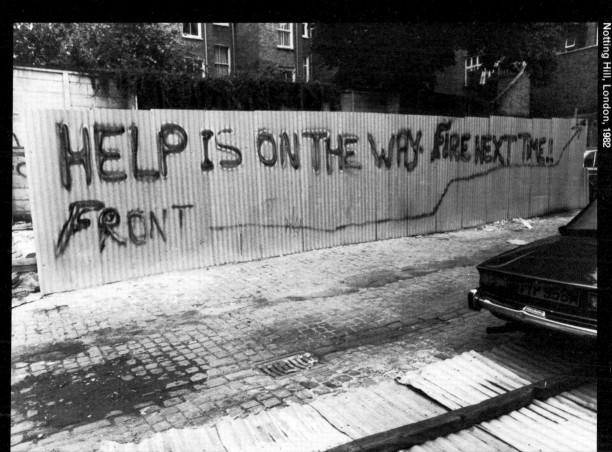

Notting Hill, London, 1982

Left: Notting Hill, London, 1982

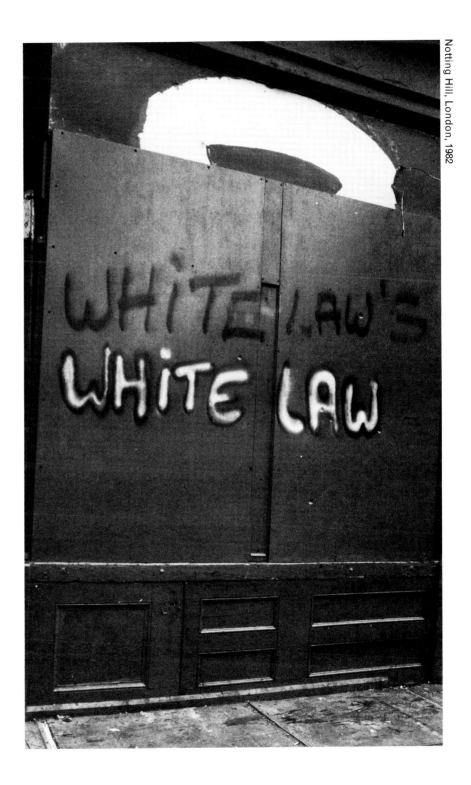

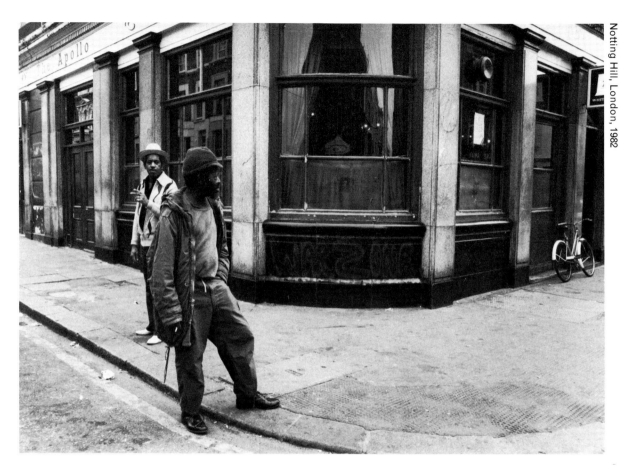

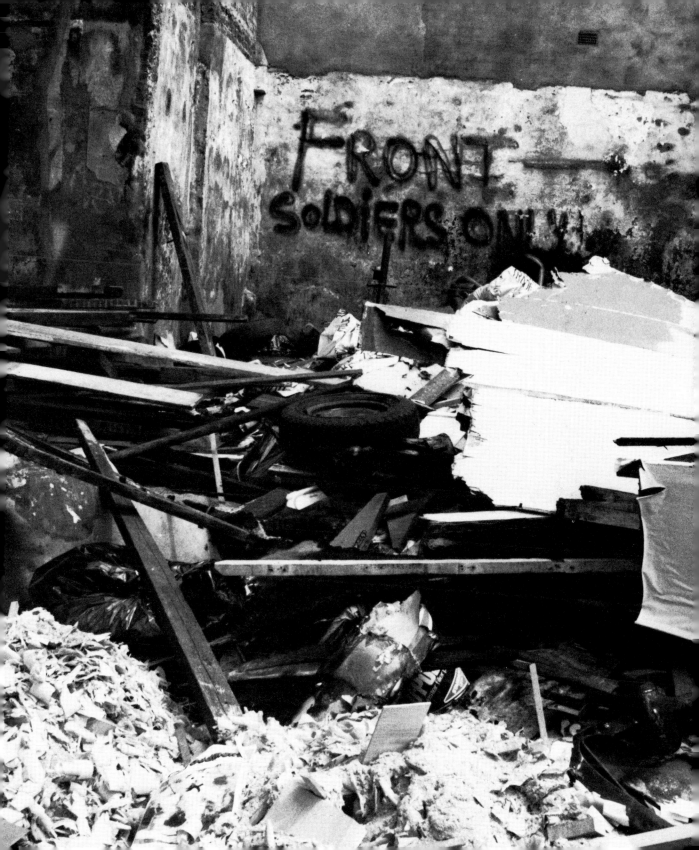

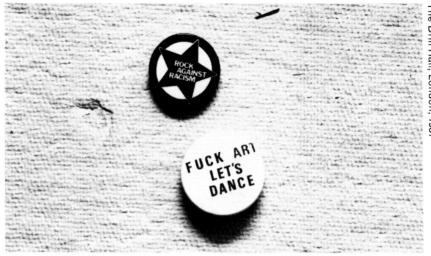

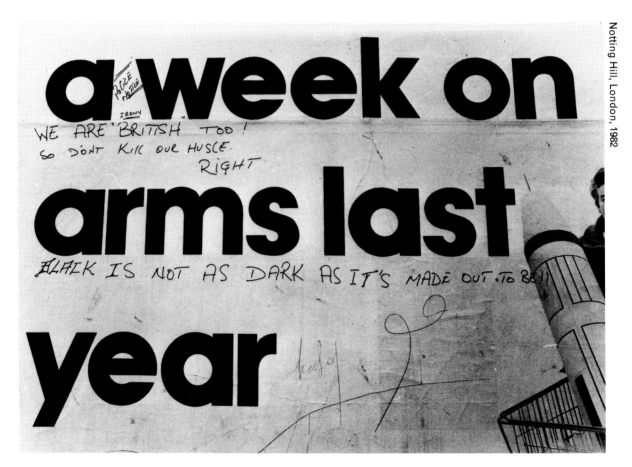

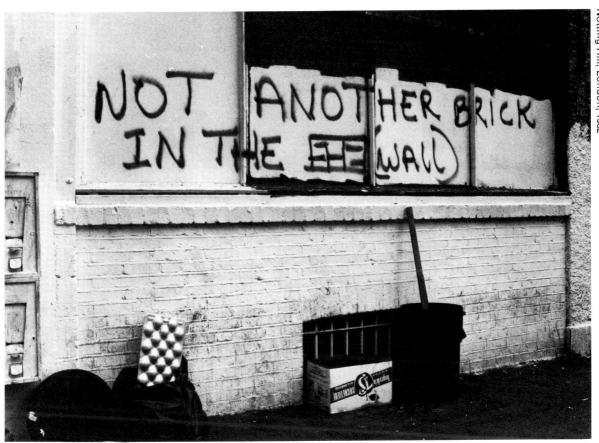

"We used simple slogans. One read, 'SDP spells homelessness'. 'Vote SDP for a rotten borough' appeared all over Islington after Labour councillors had defected to the SDP which created the first SDP local authority. One of their first actions was to change the face of housing in the borough. Sales of council properties soared and short-life housing, a mainstay for single people, was threatened with almost total extinction. With 12,000 people on the waiting list, and, according to a Department of the Environment survey, 9,000 houses empty, the situation was already critical.

"Graffiti was a very public way of voicing discontent, along with the petitions and leaflets. But it was the graffiti that brought the campaigners most of their publicity. I was arrested by a van load of SPG officers, who leapt out of the van and ordered me to put my hands in the air. 'Put your hands where we can see them', one ordered. I was a graffitist. I was treated like a major criminal."

Eventually the SDP paid the price . . . voted out of office by a potentially homeless electorate.

4
WHO NEEDS HOUSING?

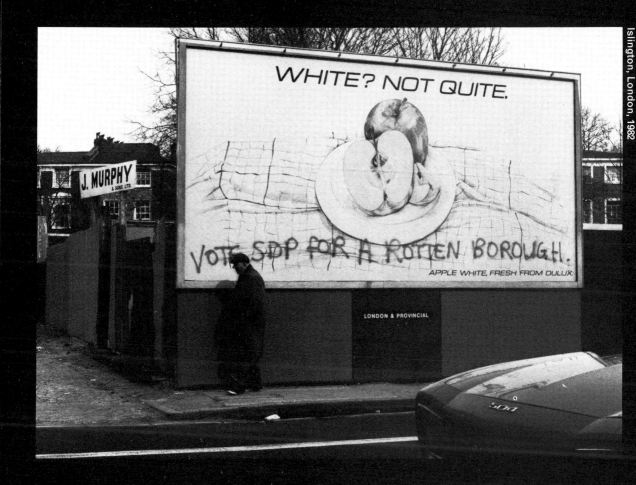

Islington, London, 1982

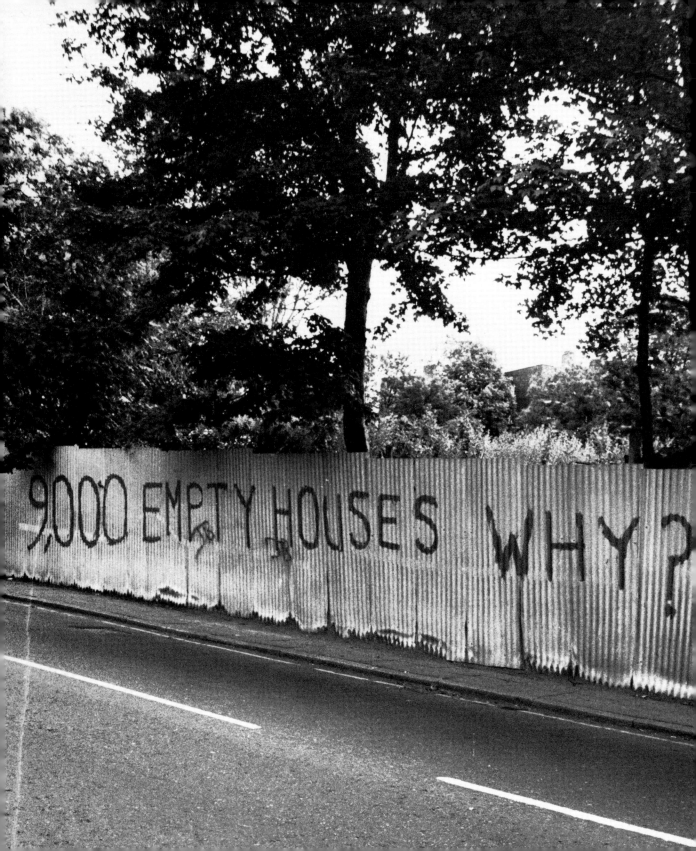

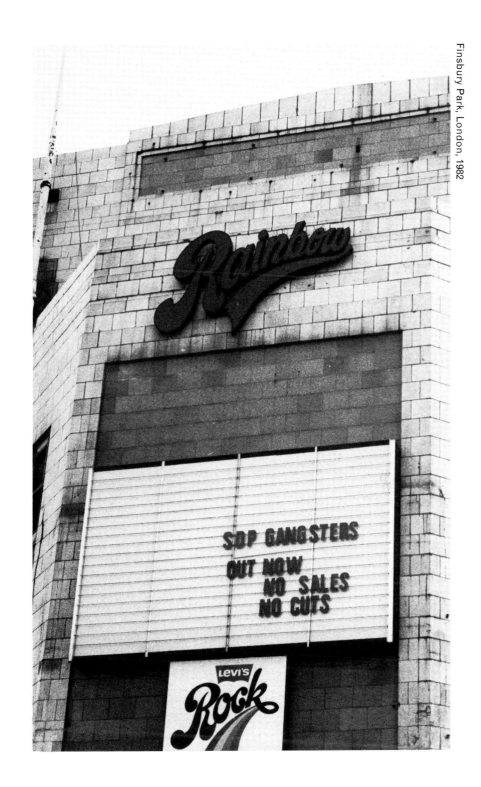

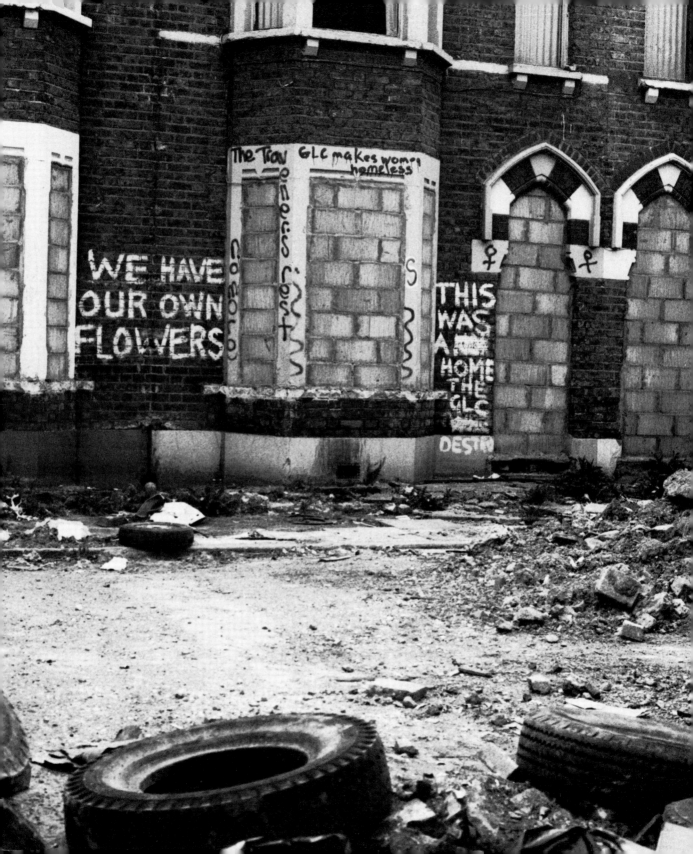

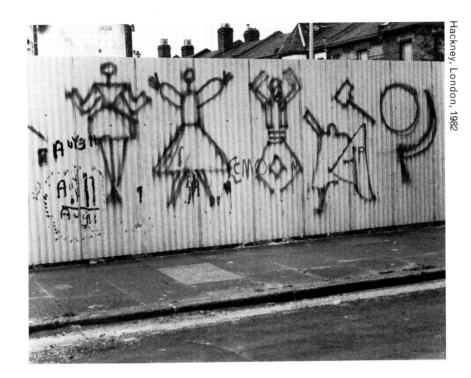

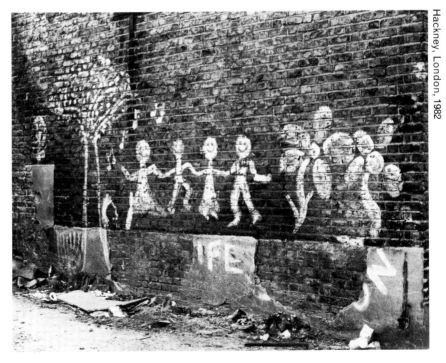

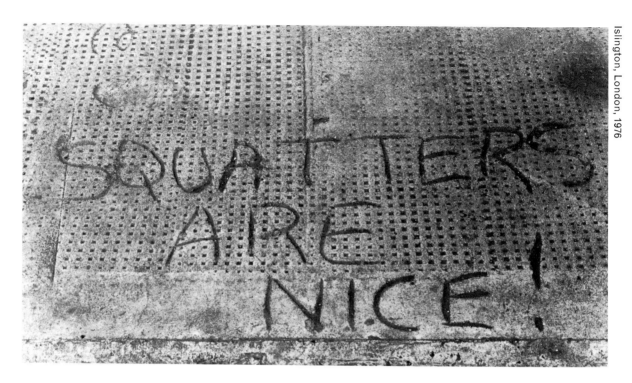

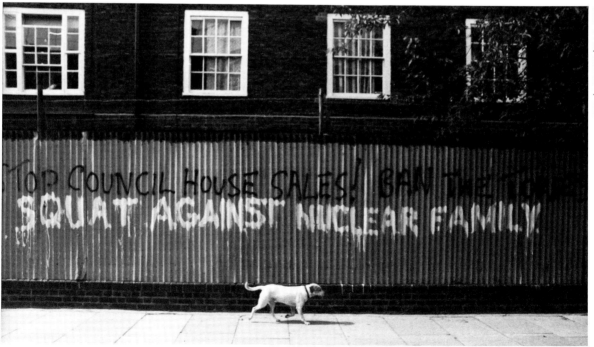

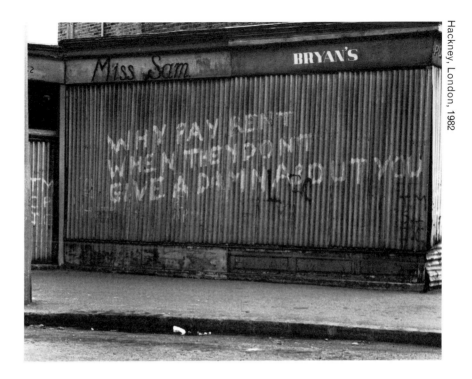

In 1649 Gerrard Winstanley led a group of people to unused land in southern England which they squatted. The Diggers practised the principles of early anarchism. Under severe pressure from landowners and the state led by Cromwell, they resisted attacks on their settlement, but eventually, when passive resistance could no longer fend off the onslaught, they departed.

"When this universal equity rises up in every man and woman, then none shall lay claim to any creature and say, This is mine and that is yours. This is my work, that is yours. There shall be no buying and selling, no fairs and markets . . . And all shall cheerfully put their hands to make those things that are needful, one helping another."

"The official figure of animals used in experiments in Britain is 5 million a year. Unofficially it could be far higher, and a rough estimate of the total around the world could be as high as 200 million per year. I would be depressed if I felt nothing could be done, but my own militancy and the actions of others have improved my outlook. There's an increasing number of people getting involved in actions to free animals. The Animal Liberation Front have saved nearly 2 million animals.

"I've served two prison sentences. One of 12 months and one of 8 months. I was convicted of Criminal Damage and burglary. I was convicted for stealing 125 mice. I've stopped illegal actions now, but I support others who do it.

"Why do we do it? Peaceful campaigns to stop the pointless slaughter of animals has been going on for a hundred years. The abuse just gets worse. I've no doubts about the morality of saving animals from torture. But we're not liberal conservationists. People truly committed to animal liberation are committed to change in society generally. It is part of a wider liberation movement."
Ronnie Lee

THE PAW RELATIONS

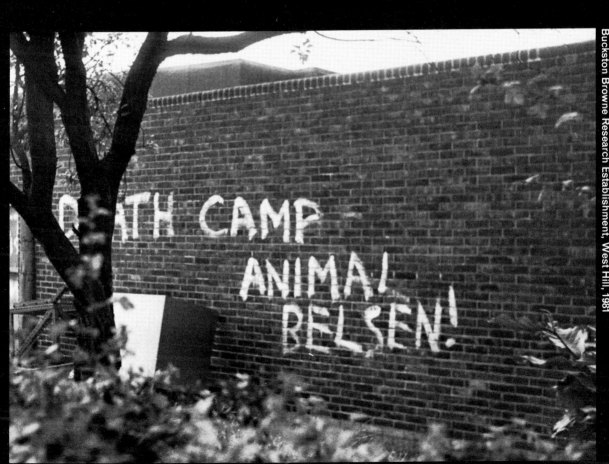

Buckston Browne Research Establishment, West Hill, 1981

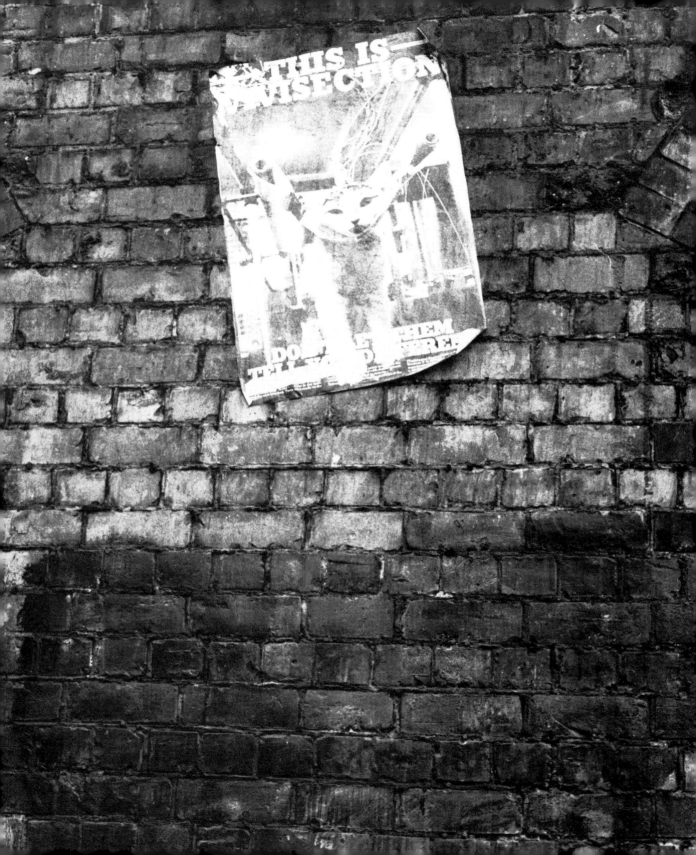

Poster and badges issued by the The British Union for the Abolition of Vivisection.

BEARSKINS ARE FOR BEARS NOT ROYAL GUARDSMEN

ANIMALS DON'T SMOKE
ANIMALS DON'T DRIVE
ANIMALS DON'T WEAR MAKE-UP
ANIMALS DON'T USE PAINT
ANIMALS DON'T DRINK ALCOHOL
ANIMALS DON'T DROP BOMBS

BECAUSE YOU DO
WHY SHOULD THEY SUFFER?

BUAV **AGAINST ALL ANIMAL EXPERIMENTS**

BUAV. 143 Charing Cross Road. London WC2H 0EE Telephone: 01-734 2691

IF A GROUSE HASN'T GOT ONE WHO HAS?

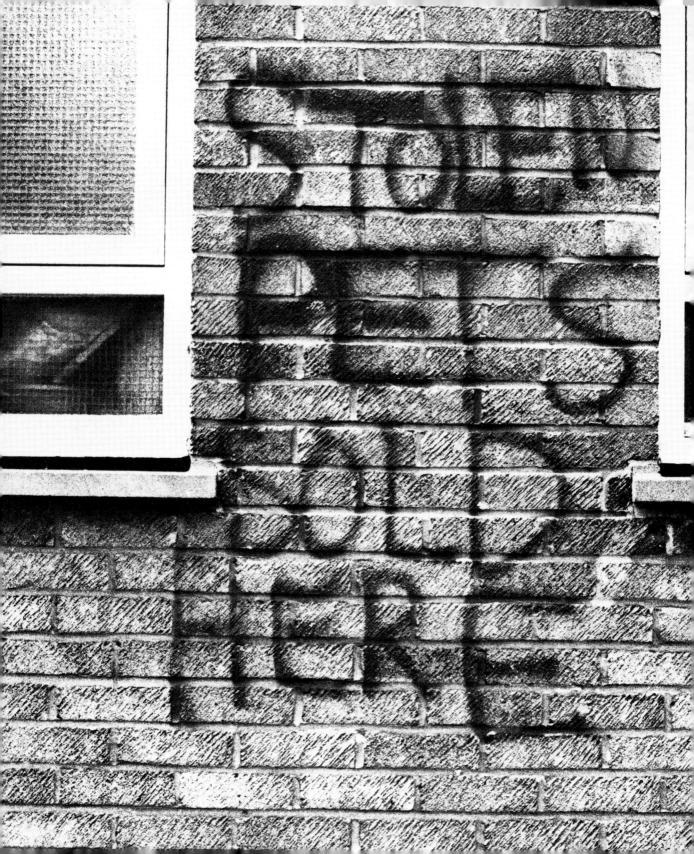

Club Row market in London's East End has been trading in stolen pets for decades. The traders have kept a low profile since the protests began a few years ago.

After some dogs were rescued in the Sheffield area by the Animal Liberation Front, photos of the dogs were displayed in the local paper. One owner recognised one dog as the pet stolen from her back garden.

Retired greyhounds and mongrels are the cheapest dogs. They are frequently used in experiments like brain transplants. After rescue, they are placed with caring homes. A huge network exists to cope with the vast quantities rescued after break-ins at laboratories.

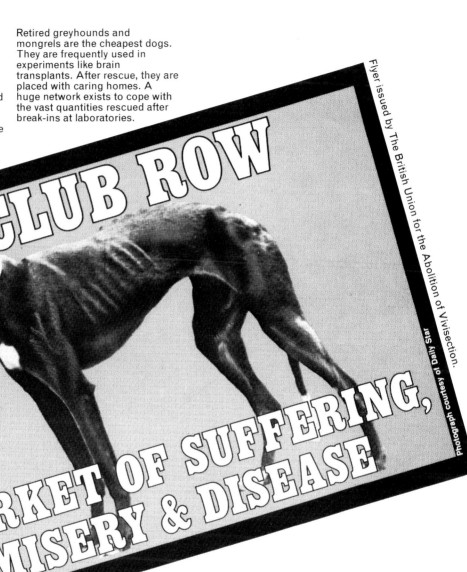

Flyer issued by The British Union for the Abolition of Vivisection.

Photograph courtesy of Daily Star.

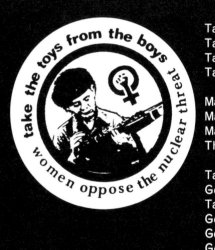

Take the toys from the boys
Take their hands off the guns
Take their fingers off the trigger
Take the toys from the boys.

Made a bomb out of cotton
Made a bomb out of sugar
Made a bomb out of music
They made a fool out of you.

Take the toys from the boys
Gotta make a living
Take their hands off the guns
Gotta make a killing
Get their fingers off the button
Gotta get promotion
Take the toys from the boys
made a bomb, made a bomb

POISON GIRLS

PROTEST
AND SURVIVE

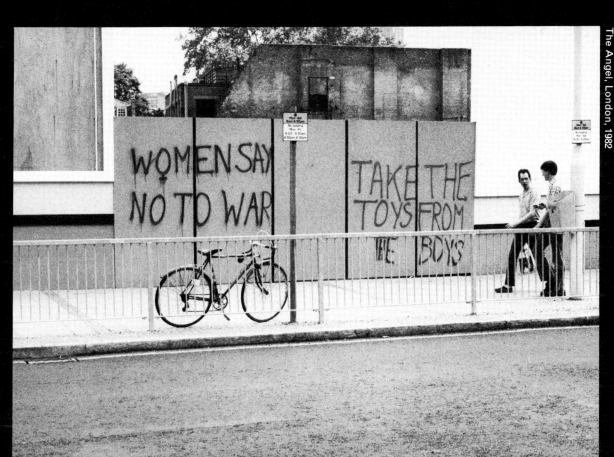

The Angel, London, 1982

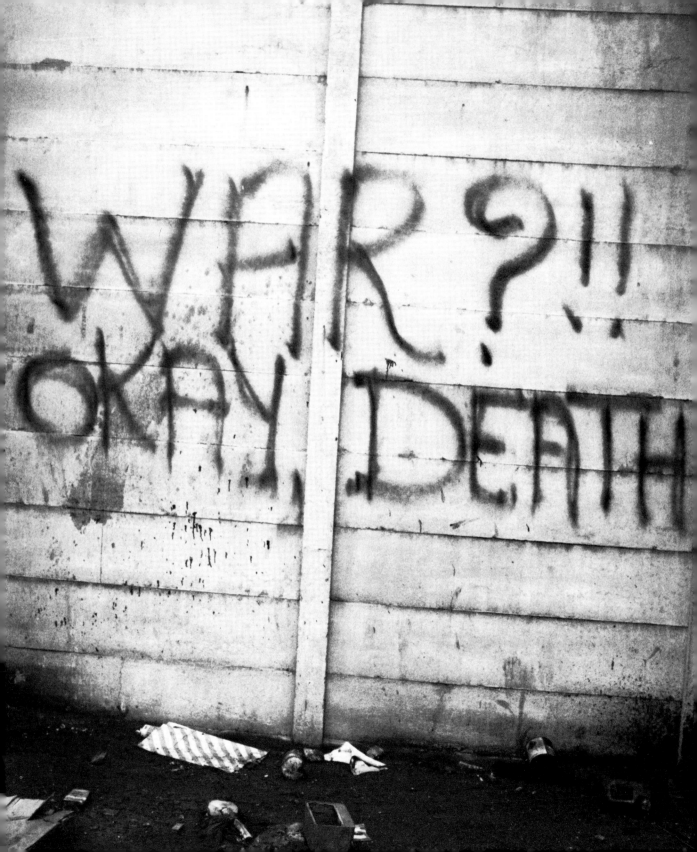

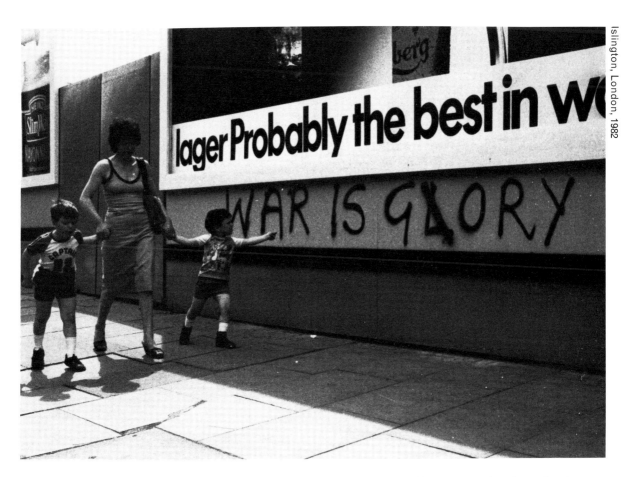

"War is the health of the state. It automatically sets in motion throughout society those irresistible forces for uniformity, for passionate co-operation with the Government in coercing into obedience the minority groups and individuals which lack the larger herd sense."
Randolph Bourne, The State, 1919

"Like the on-going war in Northern Ireland, there was little reported opposition to the Falklands war in the press. We resorted to graffiti to break the silence. We're against war, but we're saying clearly that we place the responsibility at the feet of male values.
"We know we're taking a risk, our hearts pound, but it's worth it. It actually boosts our confidence to take the power of communication into our own hands. And it encourages people who feel like we do. Most of the population have no access to the media. Graffiti is access. And of course we aim for discussion and disruption. We hope we do challenge complacency."
A woman from FANG (Feminist Anti Nuclear Graffiti)

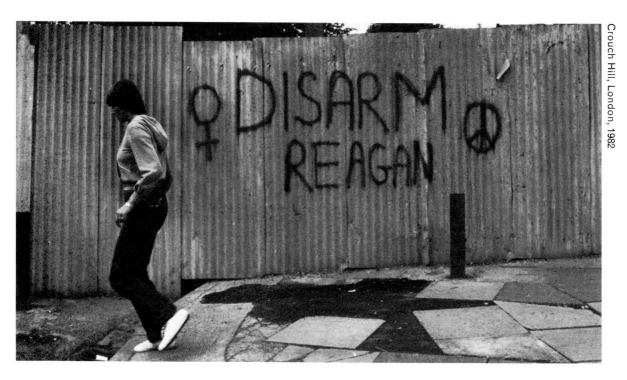

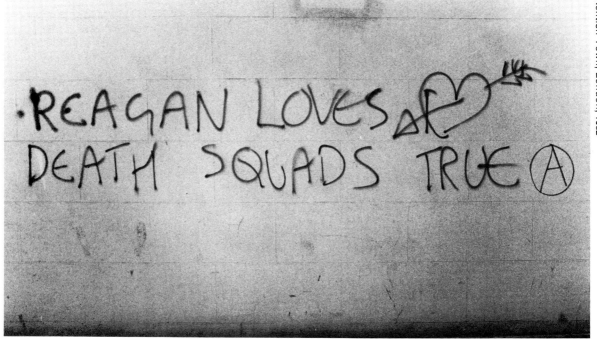

D.O.N.T.
(dykes oppose the nuclear threat).

Ealing, London, 1982

24 MAY

WOMEN'S DAY FOR DISARMAMENT

FINLAND SPAIN SWITZERLAND IRELAND AUSTRIA BRITAIN FRANCE HOLLAND

DENMARK BELGIUM ICELAND SWEDEN

PEACE
PEACE
PEACE
PEACE

DENMARK BELGIUM ICELAND SWEDEN

FINLAND SPAIN SWITZERLAND IRELAND AUSTRIA BRITAIN FRANCE HOLLAND

81

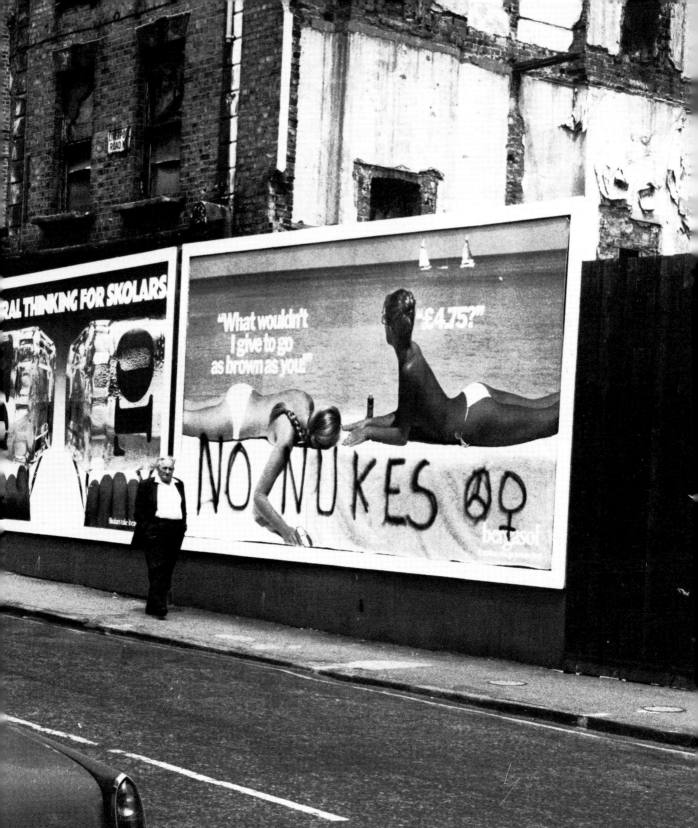

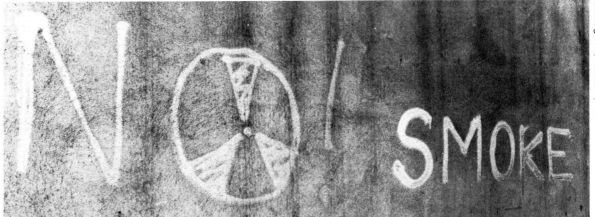

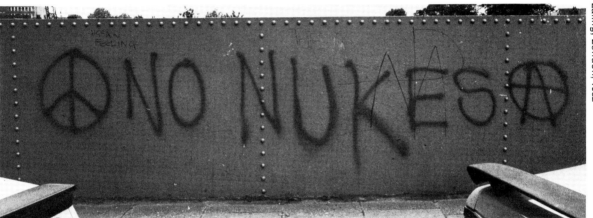

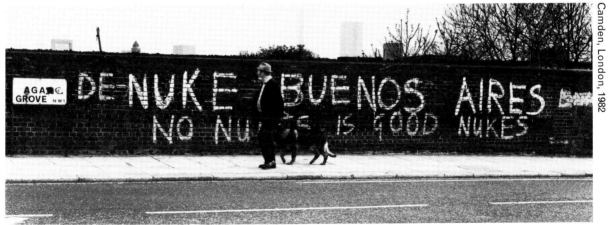

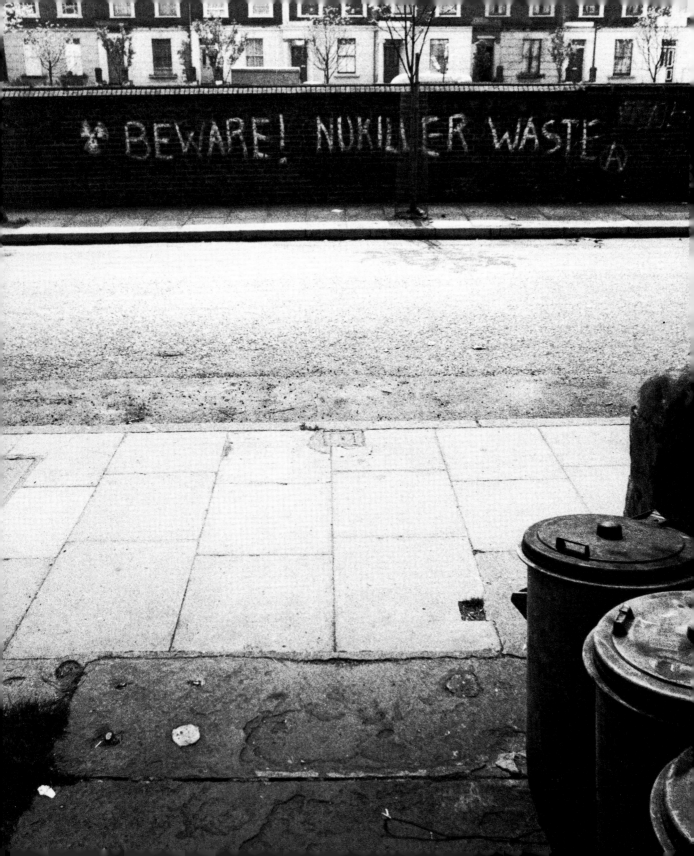

Left: Wall overlooking North London Railway Line, 1981

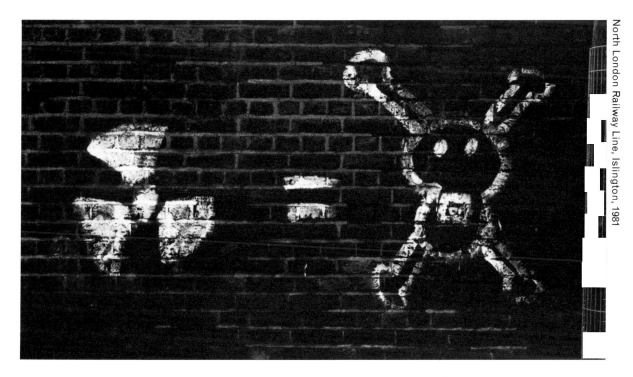

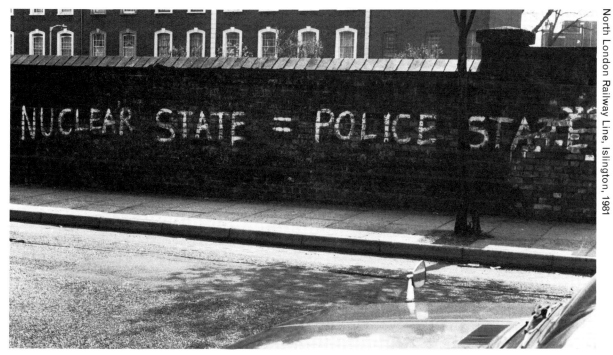

"I had just finished painting the slogan and I got on my pushbike. I noticed a police car driving up, and decided not to hang around. Not surprisingly, they pulled up beside me. 'Were you trying to ride away?' they asked. 'Oh no, officer, I was going this way anyway', I replied.

"It was one of my first spray painting efforts. I'm more careful now.

"One day my wife was out with her spray can. One belligerent man leaned out of his car and yelled, 'Does your husband know what you're doing?'

"We're not telling individuals they shouldn't smoke. We're telling the big corporations they shouldn't push drugs".

YOU SMOKE, I CHOKE

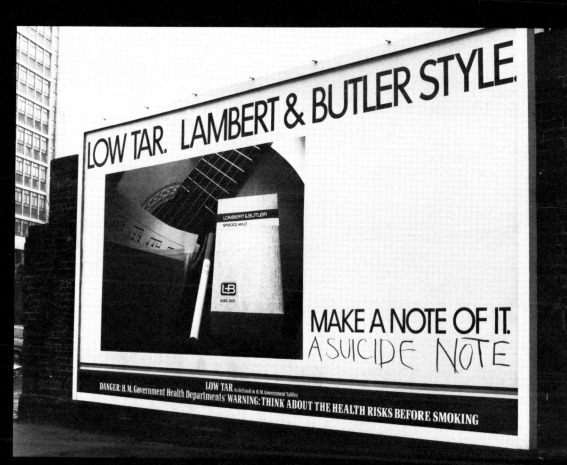

Blackfriars, London, 1982

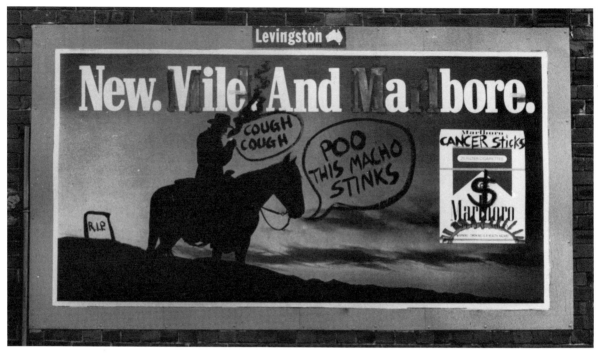

*A Billboard Without Graffiti is
Something Quite Outrageous*

BUGA UP which stands for
Billboard Utilising Graffitists
Against Unhealthy Promotions
began in 1979 after a group of
'phantom sprayers' met to
discuss how they could best unite
in their campaign against what
they saw as 'corporate drug
pushers' and the assault on the
environment in the shape of
hoardings. These days,
membership includes students
and old age pensioners, teachers,
builders, doctors and cabbies.
They would like to see all
advertising removed from our
streets and are prepared to go to
jail because of their activities. Bill
Snow, a founder member,
explained:

"We would prefer to go to jail than pay the fines imposed if we're caught.
That's one form of protest, following on from the protest we make on the
billboard. I was accused of 'malicious damage' to a billboard. I don't even swat
flies, that's how malicious I am."

BUGA UP consists of people who
feel strongly, not only about the
dangers of 'image selling' in
advertising, but the pollution
effects on tobacco. Apart from the
health dangers for smokers and
non-smokers alike, the environment
suffers. Bill Snow once announced
plans to collect every butt dropped
on Sydney streets in one day, and
dump them in the harbour. That's
three million butts. "If that doesn't
convince people. . . ."

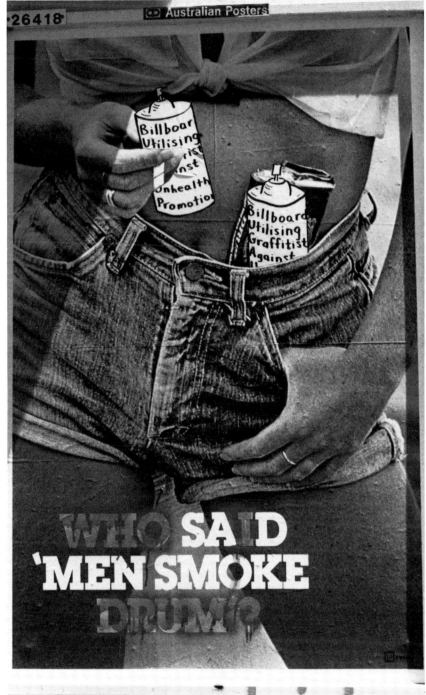

From BUGA UP's catalogue.

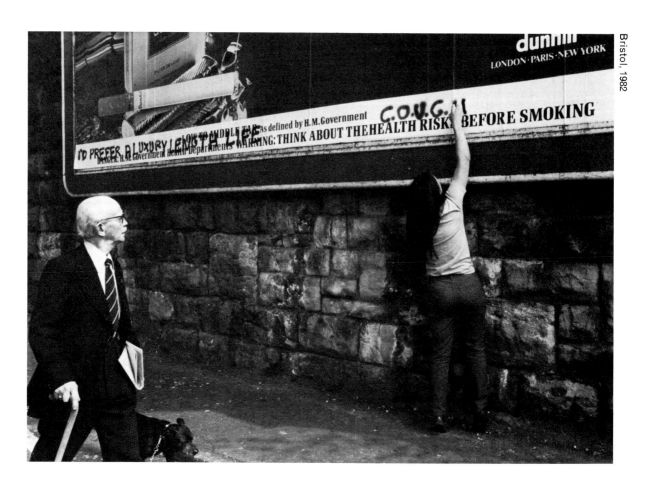

Citizens Organization Using
Graffiti to Halt Unhealthy
Promotions, COUGH UP are
Englands answer to BUGA UP.

"We started spray painting at the beginning of 1982. Our targets so far have only been the tobacco industry's ads. Cigarettes are the cause of most preventable illness in the UK. Most people get moralistic about kids starting smoking, and yet we're surrounded by ads which suggest it's cool and groovy to smoke. Hoardings dominate our environment. And they work on the unconscious, persuading people to buy without them quite realising it. COUGH UP doesn't have any money. We can't buy hoardings. So we have to take them. We'd like to see an end to all tobacco advertising. People could still buy their favourite brands in the shops. Adverts are supposed to inform. What's so informative about Benson and Hedges's packs disguised as pyramids? It's all about 'image'. We'd like to see everybody who objects to advertising taking the same action as we do. Intead of just passively accepting things, we can get up and do something."

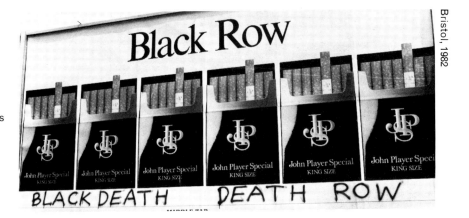

Bristol, 1982

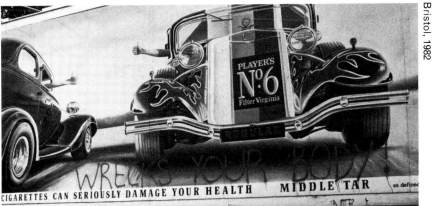

Bristol, 1982

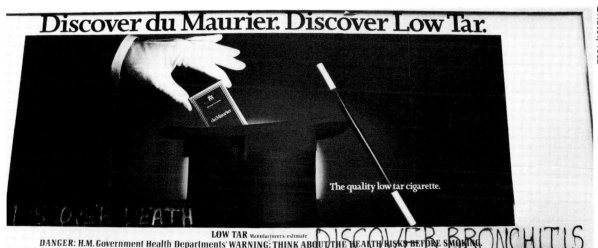

Bristol, 1982

91

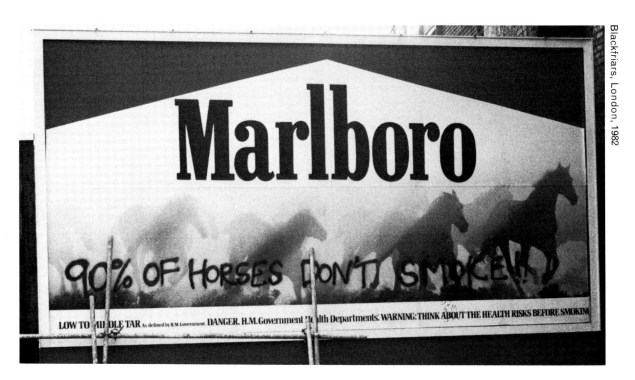

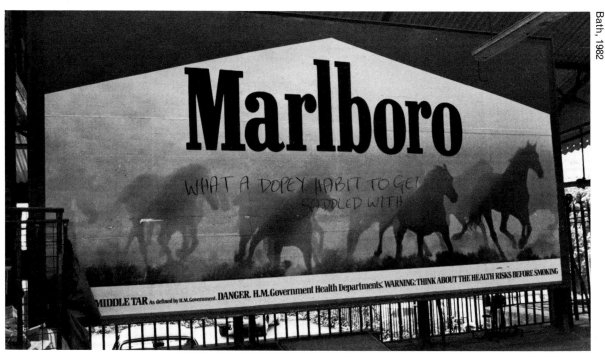

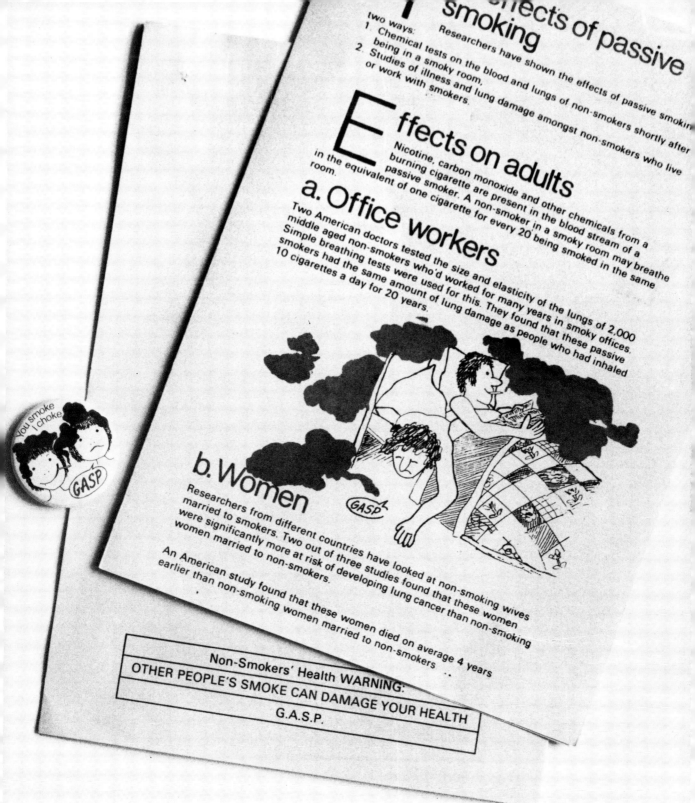

Effects of passive smoking

Researchers have shown the effects of passive smoking two ways:
1. Chemical tests on the blood and lungs of non-smokers shortly after being in a smoky room.
2. Studies of illness and lung damage amongst non-smokers who live or work with smokers.

Effects on adults

Nicotine, carbon monoxide and other chemicals from a burning cigarette are present in the blood stream of a passive smoker. A non-smoker in a smoky room may breathe in the equivalent of one cigarette for every 20 being smoked in the same room.

a. Office workers

Two American doctors tested the size and elasticity of the lungs of 2,000 middle aged non-smokers who'd worked for many years in smoky offices. Simple breathing tests were used for this. They found that these passive smokers had the same amount of lung damage as people who had inhaled 10 cigarettes a day for 20 years.

b. Women

Researchers from different countries have looked at non-smoking wives married to smokers. Two out of three studies found that these women were significantly more at risk of developing lung cancer than non-smoking women married to non-smokers.

An American study found that these women died on average 4 years earlier than non-smoking women married to non-smokers.

GASP

You smoke I choke. GASP

Non-Smokers' Health WARNING:
OTHER PEOPLE'S SMOKE CAN DAMAGE YOUR HEALTH
G.A.S.P.

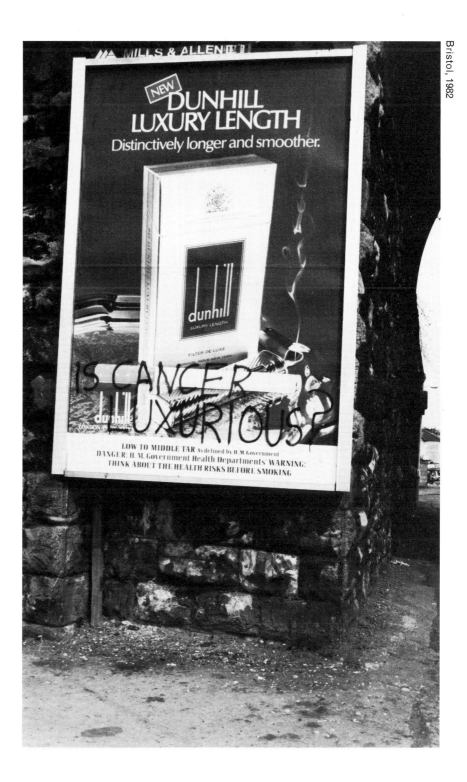

Trouble with the Law

If ever you feel the urge to add your opinion to a wall or a hoarding, always remember you are committing an offence. You can be prosecuted by the police or the owner of the property you have refaced. You will be charged with criminal damage, and if you are convicted, fines can be heavy averaging £50. If you have been caught in the act, there is little you can do, except to get immediate legal advice and help. Inform someone in advance that you intend to go spray painting, and always carry a solicitors' phone number or the number of Release's 24-hour emergency service: 01 603 8654.

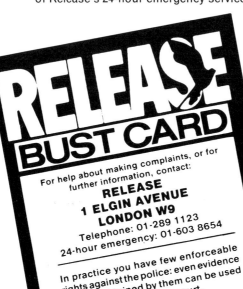

RELEASE BUST CARD

For help about making complaints, or for further information, contact:

RELEASE
1 ELGIN AVENUE
LONDON W9
Telephone: 01-289 1123
24-hour emergency: 01-603 8654

In practice you have few enforceable rights against the police: even evidence illegally obtained by them can be used against you in court.

Remember:
1. Don't get drawn into conversations with the police. Even apparently innocent remarks may be used against you. You do not have to say or write anything, or sign any statement. You have the right to refuse to answer all police questions, but you may be arrested for refusing to give your name and address if the police reasonably suspect that you have committed certain offences.
2. If in doubt, do and say nothing until you have contacted a solicitor or Release.
3. If anything you ask for is refused, ask why and remember the reason given.
4. As soon as possible, make full notes about what has happened. These can be used in your defence.

In all dealings with the police:

1. CHECK THEIR IDENTITY: ask to see their warrant card; remember the details. If they are uniformed, remember their numbers.
2. IF YOU ARE STOPPED AND SEARCHED IN THE STREET: ask the reason. The police may search you for drugs, firearms, 'terrorist' documents or articles, stolen property (only in London and some other cities) on 'reasonable suspicion' that you have any of these things in your possession—and you can be taken to a police station to be searched for these items, without being formally arrested. In all other cases it is illegal for you to be searched or be taken to police station against your will.
3. IF YOU ARE TAKEN TO A POLICE STATION:
 a) Ask if you have been arrested, and if so , why. The police must give reasons. If you have not been arrested, you are legally entitled to leave the station (except see 2 above).
 b) Ask to see a solicitor or a friend.
 c) Ask to phone a solicitor, Release, a relative or a friend. The Criminal Law Act 1977 s62 gives you the right to insist that someone be informed about your detention. You are not legally limited to one call.
 d) Ask to be charged or released. You cannot be kept at the police station indefinitely.
 e) You can refuse to have your fingerprints taken, but such refusal is likely to result in your being held until an order requiring you to submit is obtained from a magistrate. Forcibly taking your photograph is also illegal
 In order to get bail (ie released from the police station before going to court) you will probably have to satisfy the police that you have a fixed address.
 [Y]OUR HOME IS TO BE SEARCHED:
 [Th]e police do not need a warrant or your [per]mission to enter in order to arrest someone, [but] they should name the person sought. Searches [for d]rugs or stolen goods can sometimes be [condu]cted without a warrant, but in all cases you [can] ask the police to identify themselves and [the rea]son for the search.
 [A hou]se a police search without a warrant or your [permissi]on is illegal. Ask to see the search warrant. [You are] entitled to demand the reason for the search, but barring their entry could result in a charge of obstruction against you.

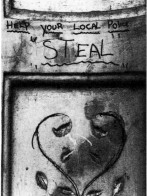

HELP YOUR LOCAL POLICE [to] STEAL

Brixton, London, 1980